START TO PAINT

with Acrylics

The techniques you need to
create beautiful paintings

Arnold Lowrey

SEARCH PRESS

This edition first published 2016

Previously published 2006 as *Painting with Acrylics*

Search Press Limited
Wellwood, North Farm Road,
Tunbridge Wells, Kent TN2 3DR

Text copyright © Arnold Lowrey 2016

Photographs by Charlotte de la Bédoyère, Search Press Studios

Product photographs on pages 8–12 supplied by Winsor & Newton

Photographs and design copyright © Search Press Ltd. 2016

ISBN 978-1-78221-326-0

The Publishers and author can accept no responsibility for any consequences arising from the information, advice or instructions given in this publication.

Suppliers
If you have difficulty in obtaining any of the materials and equipment mentioned in this book, then please visit the Search Press website for details of suppliers: www.searchpress.com.

Always refer to your supplier's website or in store for the latest ranges.

Publishers' note

All the step-by-step photographs in this book feature the author, Arnold Lowrey, demonstrating how to paint with acrylics. No models have been used.

There are references to sable and other animal hair brushes in this book. It is the publishers' custom to recommend synthetic materials as substitutes for animal products wherever possible. There is now a large range of brushes available made from artificial fibres, and they are satisfactory substitutes for those made from natural fibres.

Printed in Malaysia

Acknowledgements

My thanks to Search Press and my editors John Dalton, Roz Dace and Sophie Kersey, who have guided me unerringly to a lively, balanced book. My eternal gratitude to William 'Skip' Lawrence and Christopher Schink who turned me around, changed my direction and made me think in a fresh and exciting way about the direction of my art.

Cover
Misty Mountains
760 x 560mm (30 x 22in)

In this painting I decided to make the cottages my focal point and kept the roofs warm in colour to enhance this effect. The surrounding hills and mountain shapes were designed to lead the eye of the viewer to the focal point.

Page 1
Bad Day at Bird Rock
460 x 420mm (18⅛ x 16½in)

This was painted thickly using bristle brushes to give a juicy, painterly effect. The silhouette of the rock was featured strongly as it dominated the skyline.

Pages 2–3
Distant Fields
760 x 560mm (30 x 22in)

This was done in the watercolour style, painting on wet watercolour paper. The clouds were pulled out with paper tissues whilst the paint was wet. The rock highlights were made with a safety razor blade while wet. The soft-edged trees and reflections were produced by placing paint into the wet areas with a thirsty brush (one loaded with paint but very little water).

Opposite
Rough Seas at Yerwol
760 x 560mm (30 x 22in)

This was a demonstration painting for the South Wales Art Society. Consequently the adrenaline was flowing and it was done in less than one hour. I kept the sky plain to concentrate the focal point on the rocks and foam. There are large areas of cool colour in this painting so I decided to place some hotter colours in the headland for balance.

CONTENTS

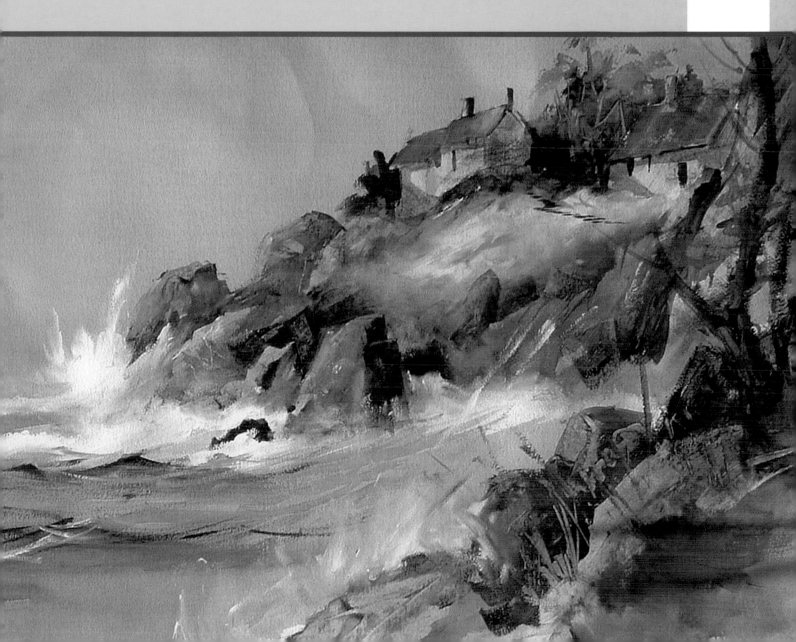

INTRODUCTION

I started painting with acrylics many years ago, and I loved them so much that I did not use anything else for ten years! They are the most user-friendly medium of the whole range of fine art materials and exciting to use. The colours are clean, bright and mix easily; they are water soluble; they can be painted onto almost any surface and they are incredibly versatile. Oil painters are now using them to underpaint darker colours, which saves on drying time, and they are wonderful when used as a collage medium with mixed media.

If you have never used this medium before, you will be happy to learn that any mistakes can be painted over easily and quickly. Different styles can be incorporated into the same painting, with colours applied thinly like watercolours, producing beautiful, transparent glazes; or thickly like oils, producing thick, textured impastos. Atmospheric scenes can be created with a series of glazes and are particularly effective, and iridescent colours are available which bend the light like oil on water. A combination of thick and thin techniques produces great paintings full of interest and depth, with a variety of textures which can be applied with brushes, palette knives and even your fingers.

I get asked many questions when I am teaching, and this book aims to answer them all. I take you step by step through a series of demonstrations which illustrate all the techniques, from washes and dry brush strokes to layering colours and building up a picture. I also explore colour and composition and show how to bring spontaneity and life into a scene, whether it is a quiet landscape or a dramatic seascape. I include many tips to help you to achieve successful paintings.

I hope I inspire you to explore this fascinating medium. It is a journey that will delight and entertain if you follow the path, practise and experiment. So, pick up your brushes and go!

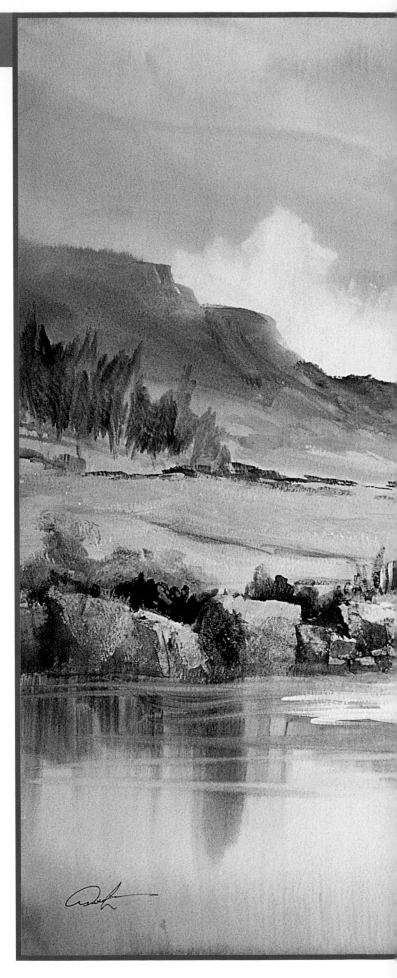

The Old Mill
730 x 530mm (28¾ x 21in)

This was painted partially in a transparent technique (the sky and the water) and partially opaquely. The shadows were glazed on adding gloss medium and varnish to the pigment.

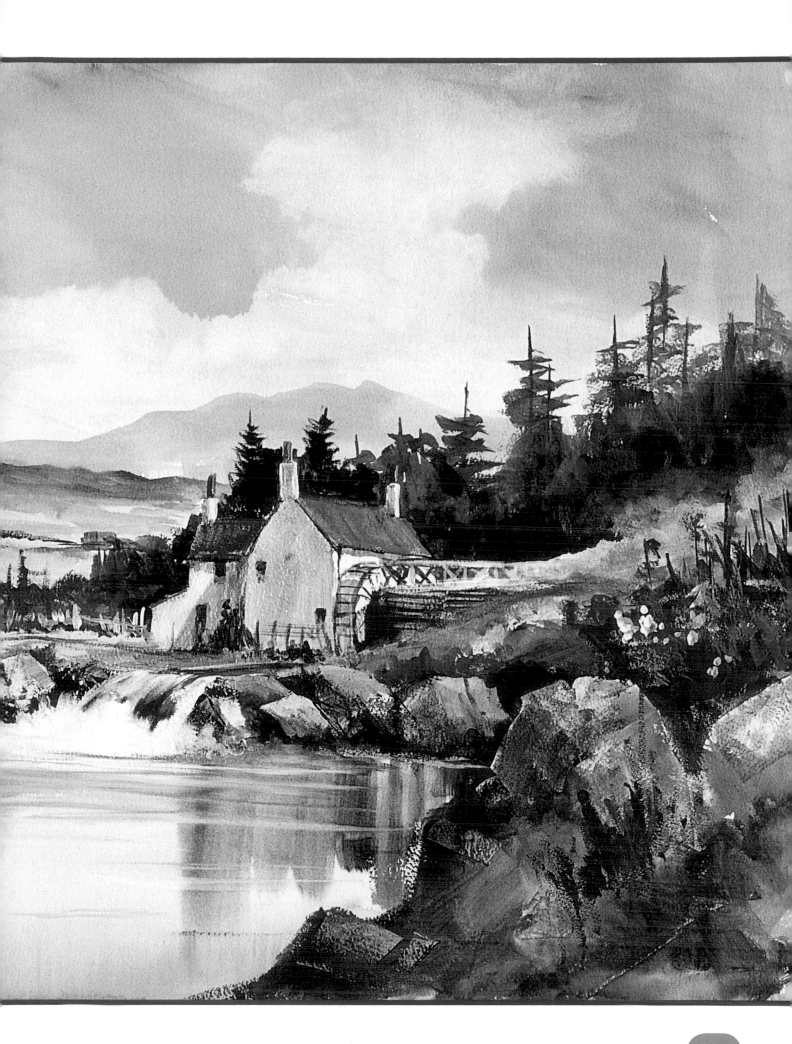

MATERIALS

Here are a few guidelines about buying all the materials and equipment you will need when painting with acrylics. You will find this advice useful if you are just starting, or if you already paint with acrylics but want to add to an existing palette.

PAINTS

All mediums require a binder which helps them stick to the painting surface. With acrylics the pigments are combined with acrylic polymer, and water which prevents them from binding together permanently. Once the water evaporates, the pigments and the acrylic polymer touch and bond, making them permanent.

Acrylics are much less expensive than watercolours, so it pays to buy the best. Professional as well as more affordable ranges are available; I prefer to use the professional quality paints because there is a larger range of colours to choose from and the paints are noted for their brilliant hues. These vibrant, durable paints have the same amount of pigment but different viscosity. Some have a buttery consistency and they are ideal for thick impasto work, while others have the consistency of cream and they are better for detailed work. The buttery paints, which are generally supplied in tubes, can be thinned down with water or acrylic medium. The creamy paints are available in 'squeezy' jars. Your choice of paint will depend on whether you want to paint thickly with the textured impasto technique, or thinly, although you can also mix both techniques.

> **TIP**
> If you get acrylic paints on your clothes you will ruin them, so always wear an apron or something to protect you. If paint does splash onto your clothes, soak them in warm, soapy water immediately.

A range of professional quality acrylic paints in tubes and jars.

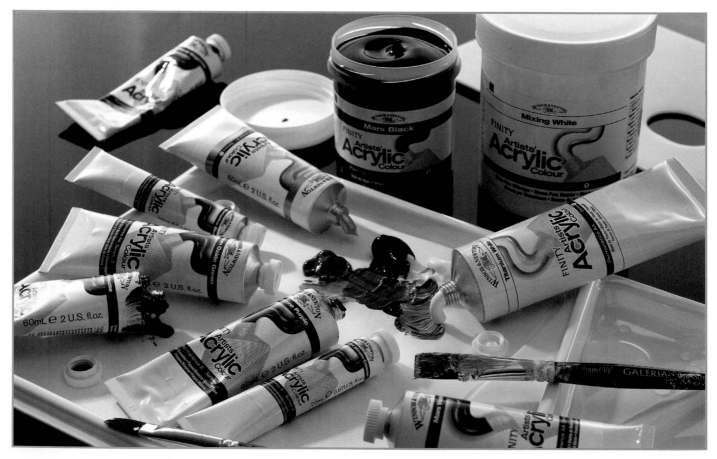

BRUSHES

I use both acrylic and watercolour brushes in a range of sizes, although I often paint a picture using just one or two. My favourites (shown right) tend to be the same brushes I use for watercolour as I paint a lot in both mediums. They are: 2.5cm (1in) and 5cm (2in) wash brushes (sable/nylon mix); a no. 3 lettering brush or rigger (sable/nylon mix); a no. 8 round (sable/nylon mix) and a 13mm (½in) one stroke (nylon) with the end specially shaped to scrape out wet paint into shapes such as tree branches.

Hog brushes (below) are strong and excellent if you want to paint thickly. I also use synthetic brushes (below right), which are flexible, have a springy feel and are good for different acrylic techniques including fine detail. A mixture of the two works well: hog brushes for the ground work and the impasto technique, synthetic for washes, thinner applications of colour and detailed work.

It is important to remember not to let the paint dry on your brushes. Always wash them thoroughly in warm, soapy water when you have finished painting. It is impossible to remove dry paint from your brushes and if left unwashed, they will be ruined.

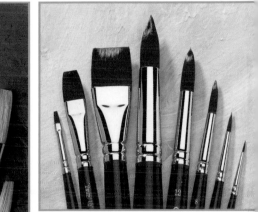

Hog brushes (above) and synthetic brushes (right) can both be used with acrylic paints.

KNIVES

I use palette knives for mixing colours. Painting knives have cranked handles to keep your knuckles out of the paint and can be used for applying paint and also gels and pastes. Razor blades work well when I am painting rocks. Painting the rocks in, then scraping the colours away with a razor blade creates realistic tones, textures and crevices.

PALETTES

There are a variety of acrylic palettes available. I like using disposable paper palettes which can be thrown away after use. The paper is non-absorbent and it is available in pads.

I also use a 'stay-wet' palette which has an absorbent material in the base, disposable papers and a lid. Water is added to the absorbent layer, one of the papers is placed over this and the paints are placed on top. This system keeps the paints moist, with the moisture in the lower paper acting like a reservoir. The paints are protected in a damp atmosphere if the lid is replaced between painting sessions.

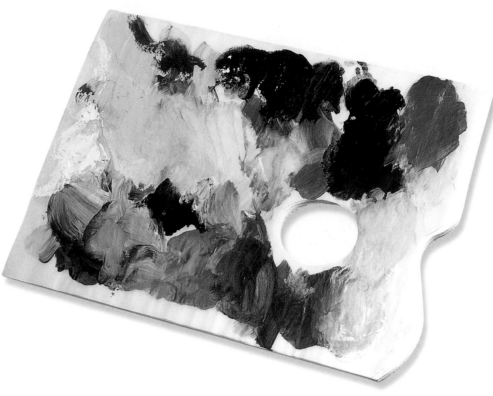

I like using a disposable paper palette like this one, which is available in pads. It can be thrown away after use and the paper is non-absorbent, so the paint stays on the surface.

SURFACES

Acrylics can be painted onto almost any surface, apart from those that are greasy or shiny. Glass is the exception. You can paint on it, but the paints will eventually peel off. If you are using an unprimed surface such as hardboard, it will have to be primed with gesso, which is available ready prepared from most art and craft shops. I prefer to use watercolour paper but I also use canvas, which can be bought in a roll or stretched on a backing frame. It is also available mounted on board, which is sold as canvas board. Textures vary from fine-grained cloth to coarser grains, and it is worthwhile experimenting with different types to find out which surface you prefer to paint on.

Canvases and boards are available already primed, so check this when you are buying your surfaces.

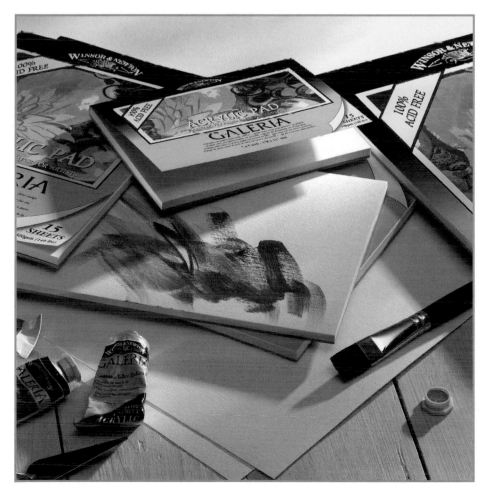

I tend to use watercolour paper for most of my acrylics because I can swing from watercolour to oil painting techniques at will. I have used NOT watercolour paper for most of the demonstrations in this book. 'NOT' means 'not hot pressed', since the paper is cold pressed through rollers to give a subtle, only slightly rough surface.

You can also buy paper specifically for use with acrylic paints and mediums in pads, single sheets or boards. The paper is acid free and is made from high quality wood-free fibre. It has a textured canvas surface and the weight is 300gsm (140lb). It is sized both externally and internally, which gives the paints a luminosity and brilliance. I find the pads excellent for outdoor sketching or studio work.

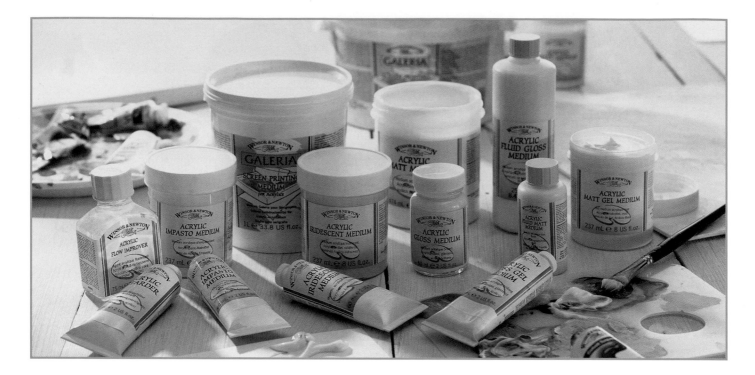

MEDIUMS

Mediums are used to create all sorts of effects including pearlescent, gloss and matt finishes. The impasto medium can be used with knife painting techniques to create textured surfaces and the retarder allows you to work with the paint longer by extending the drying time. Acrylics can be used like oils, watercolours, or a mixture of the both. Acrylic paint has its own special qualities and by combining the paint with mediums, and with the gels and pastes, many wonderful effects are easily achievable.

You can also buy a product called 'medium and varnish' in gloss and matt finishes. Acrylic paints sometimes dry with a patchy look, partly gloss and partly matt. This does not matter if your painting is to be framed under glass. However, if you do want to even out the effect, you can use a medium and varnish to varnish the painting. Lay the painting flat and apply the medium and varnish with a flat varnishing brush, using parallel strokes one way and then at right angles to even it out. The milkiness when wet will dry to a clear finish. Mixing medium and varnish with acrylic paints also makes them more transparent when applied thickly.

GELS AND PASTES

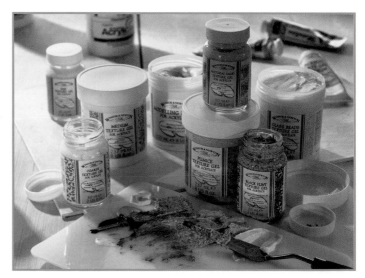

There are some wonderful gels available and they can be used to create exciting textural effects. glass beads texture gel is fun when combined with paint and can produce interesting results. You can also buy fine, medium and course texture gels which are ideal for landscapes, seascapes and buildings. Modelling paste remains flexible on a number of surfaces and can be carved, sanded or overpainted, so it can be sculpted into rock features, or used to highlight elements in a painting. Beaches may benefit from the addition of sand texture gel, and black lava texture gel produces a speckled appearance.

OTHER EQUIPMENT

I also use:

An easel I usually use the lightest aluminium easel I can find for painting outdoors. These can be affected by wind so suspend a large stone on string from the centre to weigh it down. In the studio you can use a heavier, more stable easel.

Pencil 2B, or 4B will be softer if you have a lot of rubbing out to do!

Eraser I use a kneadable putty eraser.

Water pot Use one which holds plenty of water as it dirties quickly when you are using acrylics.

Sponge To remove wet paint quickly, both for softening edges and removing mistakes.

Masking tape I use this for two main purposes: I stick it around the edge of the paper to create a nice border edge when the painting is finished. I also use it to apply to paintings when I want to paint up to a straight line, for instance for the horizon. Painting between two strips close together can produce the mast of a boat if your hand is a bit shaky. Get draughtsman's tape if you can as it is less sticky and will not tear the paper.

Bulldog clips For attaching paper to your painting board.

Sandpaper For sanding down modelling paste where required.

Hairdryer I use this to speed up the drying process when I am in a hurry, particularly when applying multiple glazes of gloss medium and varnish. Each glaze must be completely dry before the next is applied.

Kitchen paper I use this for dabbing out clouds from wet skies and also for the mundane job of cleaning my hands.

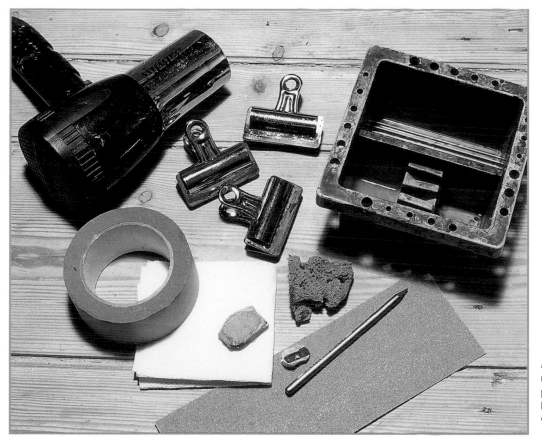

A hairdryer, bulldog clips, masking tape, sponge, pencil, putty eraser, and sharpener, kitchen paper, sandpaper and a water pot.

USING COLOUR

Acrylics are available in a wide range of colours and I love using them because of their versatility, the cleanness and brightness of the colours, and the fact that they mix well. It can be confusing if you are just starting to paint, however, because some colours, such as cobalt blue, are available from more than one manufacturer. It is wise, therefore, to experiment with the paints you buy to find out which ones you prefer, because qualities vary between different brands.

There are a few simple rules to follow when using and mixing colours, which I have set out on these two pages.

MY PALETTE

First of all, the colours that I use regularly are shown on this page. I like them because they allow me to mix the colours I want. I also use titanium white. You might want to use the same ones to start with, but you will probably develop your own palette as you get more used to working with them.

My colours are split into two groups: a basic palette and several exotic colours. I do not lay them all out on my palette before I start. I choose the ones I think I will need, then I make sure that I have enough available. It is better to be a little generous with the amounts that you squeeze out, rather than not having enough. It can be tedious if you run out of a colour while you are painting.

Basic colours

Cadmium red light	Lemon yellow
Permanent rose	Cadmium yellow medium
Ultramarine blue	Yellow ochre
Cobalt blue	Burnt sienna
Phthalo blue green shade	Burnt umber

Exotic colours

Fluorescent pink	Dioxazine purple
Bright aqua green	Cadmium orange
Brilliant yellow green	Light blue permanent

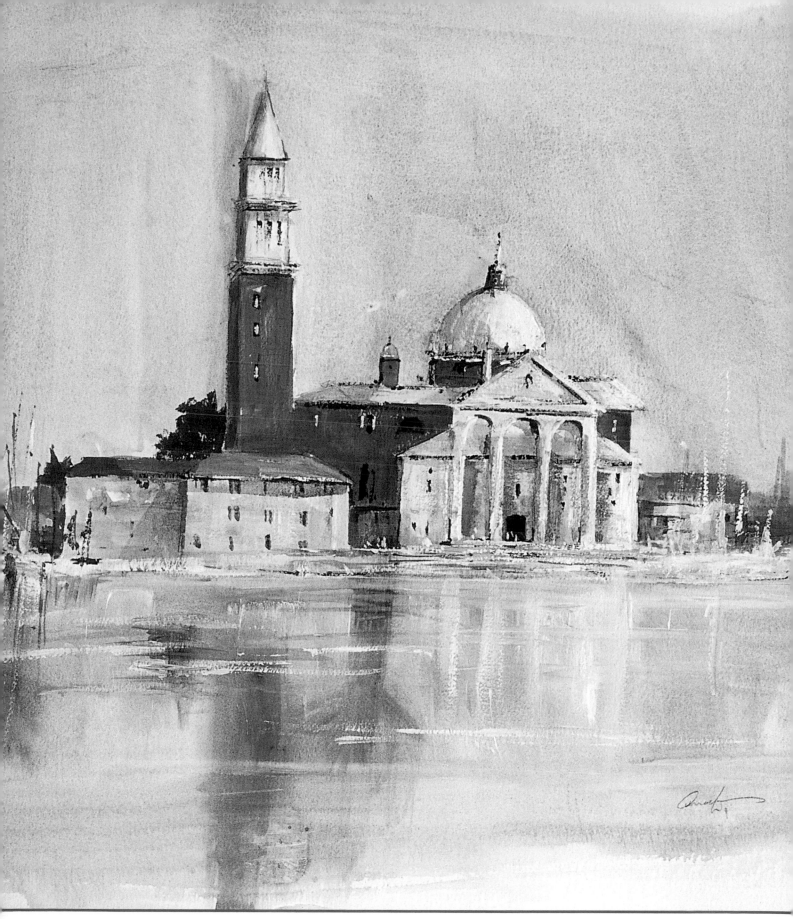

St Giorgio's, Venice in Sunlight

530 x 470mm (21 x 18½in)

The buildings were painted opaquely with intense, bright colours. A low intensity, grey-blue sky in the background helps to accentuate them. The reflections were kept soft and fluid to enhance the focal point of the buildings.

CHARACTERISTICS OF COLOUR

Pure colours are fresh and bright, and they are found around the colour wheel, grading through from red, orange, yellow, green, blue, purple and back to red. These colours are sometimes called clean, or spectrum colours, because they are pure and clean and they appear in the spectrum. The reds, yellows and blues are known as primary colours. The greens, oranges and purples are known as secondary colours.

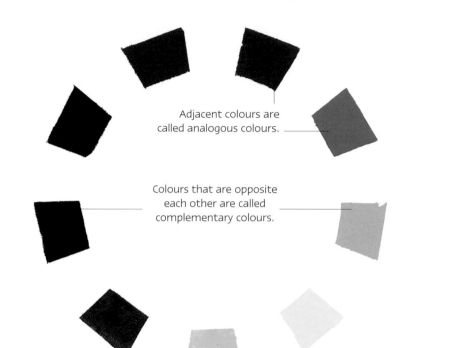

Adjacent colours are called analogous colours.

Colours that are opposite each other are called complementary colours.

Colour wheel

The colours around the wheel are known as spectrum colours.

Tonal value

Tonal value refers to the lightness or darkness of a colour and it is an important part of the painting process. Without it a picture would be flat, dull and lifeless. If you add grey, or a complementary colour plus white to a colour, the colour becomes a tone.

Hue

Hue is the term for the spectrum colours. When the hue is pure, its intensity is at its brightest and cleanest.

Intensity

This is the brightness of the colour and it is found in the spectrum colours around the edge of the wheel. Intense colours add life and sparkle to a painting and offer strong warm or cold contrasts. Adding a complementary colour reduces the intensity. Here a touch of blue has been added to orange.

Mixing colours

Mixing colours is fun, and you can use just a few to create an exciting palette. You need to know a little bit before you start. The primary colours: red, yellow and blue, are not perfect colours; they contain touches of the other primaries. For example, it is not possible to buy a perfect red, because each red contains a touch of either blue or yellow, for instance permanent rose contains a touch of blue and cadmium red light contains a touch of yellow.

In order to mix purple correctly, i.e. a clean purple, mix permanent rose with ultramarine blue (both have a touch of red). Only two primary colours are present in this mix: red and blue, so the colour remains clear and pure.

Permanent rose Cadmium red light

If I had tried to create purple with cadmium red light and phthalo blue (both have a touch of yellow), the result would have been a dirty colour. This is because all three primary colours are present in the mix.

Permanent rose Ultramarine blue Purple

So, if you create a mix using two primaries, the result will be a vibrant, clear colour. If you mix a colour using three primaries, the result will be a grey, dirty colour.

Cadmium red light Phthalo blue Dull purple

Shades, tints and tones

Hues, which are clean spectrum colours, can be muted into shades, tints and tones.

A shade is darker than the hue and is made by adding some black or a complementary colour.

A tint is lighter than the hue and is made by adding white or water.

A tone is lighter than the hue and is made by adding grey or a little of the complementary colour.

MIXING GREENS

It would be very easy to buy ready-mixed greens, like Hooker's green or viridian. However, it is just as easy to mix your own, and you can achieve just the right tones by simply mixing yellow and blue. Creating a feeling of perspective and depth in your landscape paintings is important, and you can achieve this if you know how to create the right tones.

Green consists of yellow (a light tonal value) and blue (a dark tonal value) and the two are mixed in various proportions depending on the colour you want. When mixing them together, always start with yellow and add touches of blue, a little at a time, until you have the right green. If you start by adding equal parts of yellow and blue, the yellow will be drowned out by the darker blue and you might not be able to create the green you want.

Clean greens

Clean colours are pure, vivid, colours which contain only two primary colours, in this case yellow and blue. To create a pure green, use only the yellows and blues that contain these colours. Some contain red, and if these are used, the result will be grey and dull.

A clean green A dirty green

Intense, vivid and cold greens, like the ones in the painting below, are produced with a mix of lemon yellow (a blue yellow) and phthalocyanine blue (a slightly yellow blue). Neither of these colours contain any of the third primary colour – red. However, a touch of red added to the mix can reduce the intensity of colour and neutralise the brightness of the greens. For example a grey-green is perfect for oak leaves, or contrasting softer tones. Using cadmium yellow medium and ultramarine will again create a duller green because each has a small amount of red in its make-up.

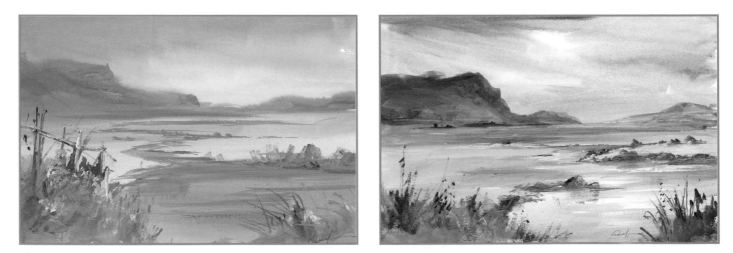

These simple paintings were each created using just two colours: on the left, lemon yellow and phthalo blue were used and the results are clean, cool colours. On the right, cadmium yellow medium and ultramarine blue were used to create a warmer but more neutral result.

The formula for greens

There is a simple, effective formula that I use and if you follow this, it will remove any confusion. You will soon begin to understand how to create a variety of greens and feel comfortable mixing your colours.

There are three questions you should ask to get the green you want:

1. Do I want a warm or a cool green?

For a cool green, use lemon yellow (a 'blue' yellow). For a warm green, use cadmium yellow (an 'orange' yellow).

2. Do I want a light or a dark green?

The more blue that is added to the mix, the darker the green will be.

3. Do I want a clean or a dirty green?

Use phthalo blue (a 'yellow' blue) with lemon yellow and the green will be clean because there is no red present. If you want a dirty green, use cadmium yellow, which contains a touch of red.

When phthalo blue is mixed with a yellow that contains a touch of red, for example an 'orange' yellow such as cadmium yellow, it creates a warm green.

The example below shows how greens can be varied. The centre line of the diagram shows lemon yellow being mixed with phthalo blue to create various hues. The bottom line shows what happens when you add white to each mix to create tints. The top line shows what happens when you add black or a complementary colour (purple) to each mix to create shades.

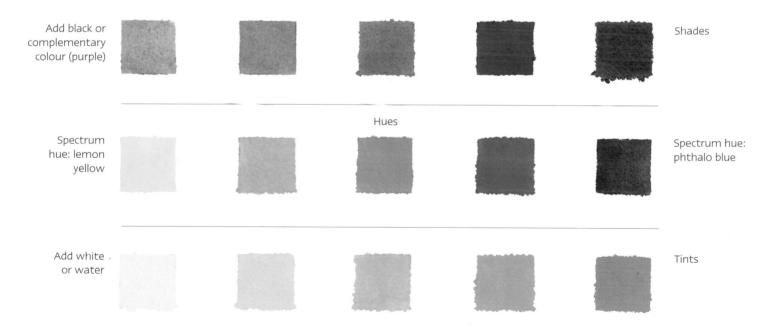

Add black or complementary colour (purple) Shades

Hues

Spectrum hue: lemon yellow Spectrum hue: phthalo blue

Add white or water Tints

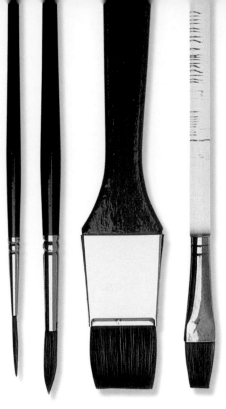

GETTING STARTED

Painting is about putting marks of paint on a surface with imagination and skill. You cannot make a sky or a boat or a cottage; the best you can do is make some marks or symbols on a flat surface of paper or canvas to represent them. This can be done with a variety of tools: brushes, painting knives, even your fingers!

Acrylics enable you to put a wide variety of marks down and this makes painting more interesting. You can paint thinly or thickly in a variety of ways, and this section will show you how to use each method. Acrylics can also be applied in various textures using mediums, pastes and glazes.

BRUSH STROKES

Here are a variety of marks created with different brushes to show some of the versatility of this medium. You will discover many more as you explore acrylics.

A damp brush used on dry paper

A wet brush used on dry paper

A sparkle effect created by laying the brush parallel to the paper

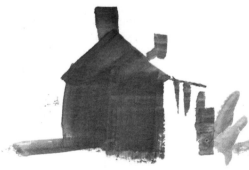

Flat brush marks

Brushing on thickly, as with oils

Rigger brush marks

Using a painting knife, as with oils

PAINTING THINLY, AS WITH WATERCOLOUR

As with watercolour paints, you will find that some acrylic colours are more transparent than others. Read the information on the tube and you should discover which colours are transparent and which are opaque or semi-opaque.

Acrylic colours can be thinned down with water on your palette and applied to the paper with a brush. However, the less transparent colours do not thin down as well as watercolours, and you need to aid the process by adding extra acrylic medium (gloss medium and varnish) to the mix. This increases the dry film thickness of the paint and helps to spread the pigments.

Painting skies

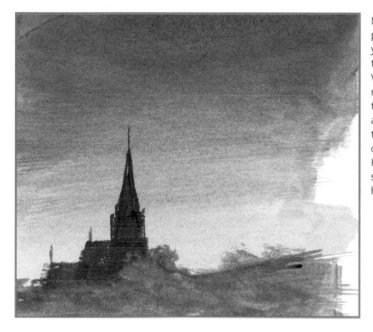

Mix a blue with water in your palette to the tint or tone that you want and paint in the top of the sky, brushing in all directions. While the paint is still wet, add more water to the mix and begin to paint the lower sky. Continue adding more water as you paint towards the horizon. Paint quickly – it is only a piece of paper! Here I have added land and the silhouette of a building to show how effective this can be.

TIPS
Unlike watercolours, acrylics tend to dry the same colour as when they are wet.

Always have your painting surface at an angle to allow any excess water to drain down to one edge, where it can be removed.

Always apply paint in a variety of directions where you want to avoid a streaky sky.

Clouds can be added easily while the paint is wet by dabbing them out with a paper tissue. The effect created is shown above.

If the sky area has dried, don't panic – you can add clouds with a bit of white paint on the end of your finger. The results of this technique are shown above.

If the sky has dried and you are not happy with it, mix the colour again, but this time add white instead of water. You can then paint opaquely over the original sky.

PAINTING THICKLY, AS WITH OILS

Acrylic paints can be applied thickly like oils, using either brushes
or painting knives. Painting in this way produces a juicier texture.
Remember, when they dry, you cannot remove them, but don't panic –
you can paint over the top of them if you are not pleased with the result.

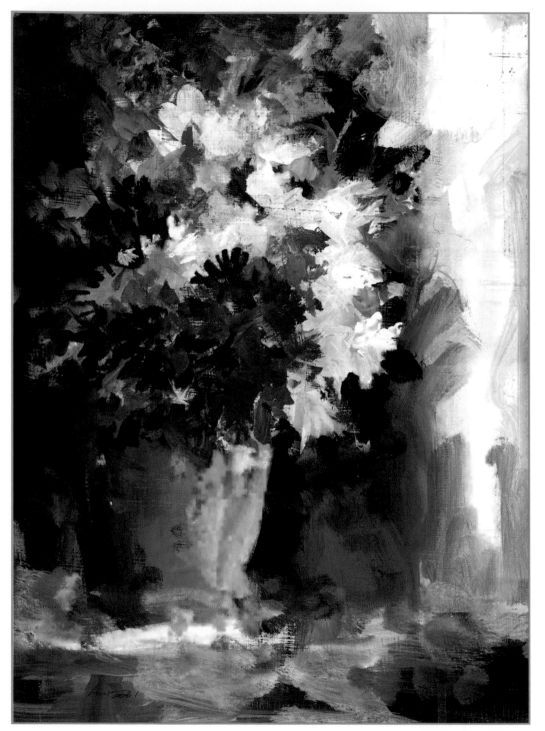

Flowers at Sunrise
300 x 410mm (11½ x 16¼in)

Here the whole picture was painted opaquely using oil techniques. Early morning
creates powerful shadows with large changes in tonal value. This effect was created
using freely painted strokes of thick opaque paint with bristle brushes.

PAINTING WITH MEDIUMS

There are many acrylic mediums on the market. They all alter the texture of the paint and tend to slow its drying, because the mix dries to a denser dry film thickness. Some mediums, known as retarders, are specifically made to slow the drying process. Others, known as 'medium and varnish', spread the pigment density of paints, making them more transparent.

Mix acrylic paints with a fifty–fifty mix of medium and water in order to use the oil painting technique known as glazing, in which a transparent layer of paint is applied on top of dry underpainting, without obscuring the form or texture underneath.

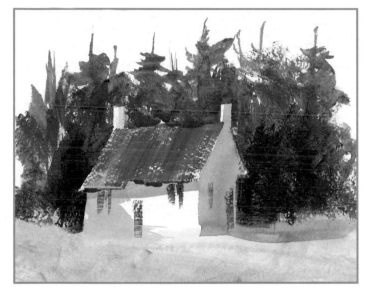

All the shadows in this painting, both on the house and the grass, were applied using a glaze on top of dry underpainting.

Some glazes have special properties – this example shows red and violet glazes mixed from acrylic paint and iridescent medium, painted over a black background.

PAINTING WITH PASTES AND TEXTURE GELS

There are many pastes and texture gels available, producing a variety of finishes, a few of which are shown here. Gels and pastes can dramatically increase the thickness of the paint, creating many different effects. There is even one, known as black lava, which gives the immediate feel of a shingle beach. I have added some colour to these samples and applied them using a painting knife.

Natural sand texture gel

Blended fibres texture gel

White opaque flakes texture gel

Black lava texture gel

Modelling paste

Gloss heavy gel medium

COMPOSITION

Before you start painting, it is good to think about what you want to achieve. I always ask myself a series of questions first to help me to focus on the subject, composition and colours that I need to express myself effectively.

The first question you should ask yourself is: 'What am I going to paint?' A good place to begin is to paint what you are interested in, whether it is flowers, seascapes, buildings, figures or abstract pictures. You may have some sketches of places you have been to, or photographs of your garden or a landscape you particularly like. Decide on your source material first.

Now ask 'Why do I want to paint this picture?' Look at your subject. What is it that excites you about it? Is it the colours, the dappled light and shade on a park bench, the compelling atmosphere of a foggy harbour or the beauty of a figure? It is this magic ingredient that, as an artist, you need to capture in your painting.

The next question is 'How am I going to achieve this?' There are a few simple rules that will help you. Composition is important, so let us take a building as an example and make it the focal point of the painting.

Focal point

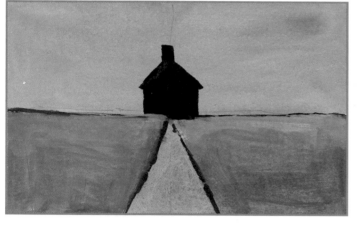

Figure 1 The focal point should never be placed in the centre of a painting – it just does not look right. The composition is dull when it is has equal space all around it, no matter how interesting the background is. It is better to create some interest, and this can be done by simply moving the focal point to a more pleasing position.

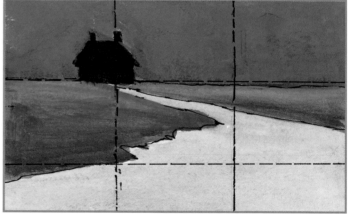

Figure 2 Many artists use the rule of one third, known as the golden section. It is not the only way to create a good composition, but it always works. Here, the painting is divided into three sections and the house is placed one third in from the left-hand side. This immediately becomes a more interesting composition.

Shapes

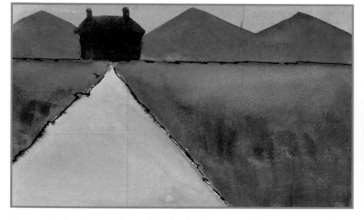

Figure 3 The shape of your focal point is extremely important. If it is not interesting, the painting will never hold your viewer's attention. Compare this figure with Figure 4. The shape of the house becomes more interesting simply by altering the angle.

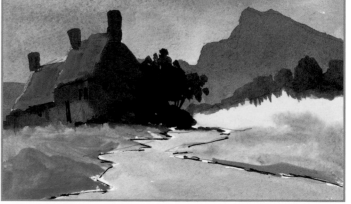

Figure 4 If other shapes are included in the painting, they should complement the focal point and enhance the scene, so make sure they are interesting too. Think of the shapes as though they are all part of an interlocking jigsaw.

Size

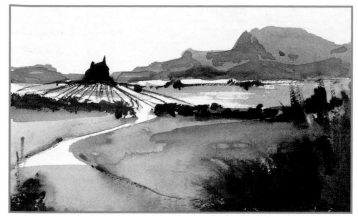

Figure 5 Deciding on the size of the elements in a picture is important. If the house is of no great interest to you, it could be painted as part of a landscape.

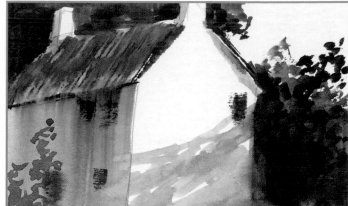

Figure 6 If the house really interests you, it could be made more prominent. Here the contrasting patterns of light and shade on the side wall enhance the painting.

Tone

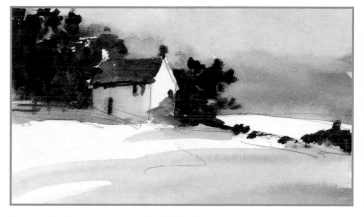

Figure 7 The painting can be divided into a range of tones: lights, mid-tones and darks. Using the full range gives a bright, punchy picture.

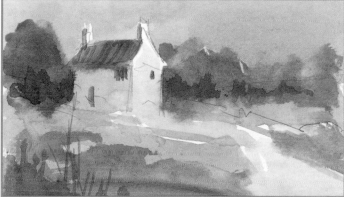

Figure 8 Reducing the tonal range can give a totally different feel to the painting. Here I have used lights to mid-tones only.

Texture

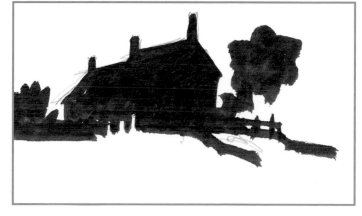

Figure 9 If your shapes have hard edges all around them, they will have a 'stuck on' quality, which will detract from the harmony of the painting.

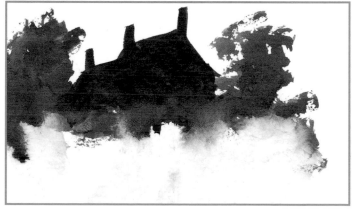

Figure 10 Changing the texture of the edges from hard to soft and rough harmonises the shape and integrates it into the painting.

Light and shade

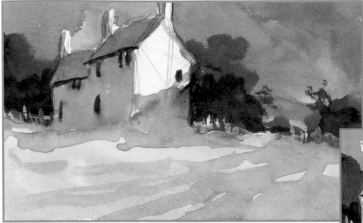

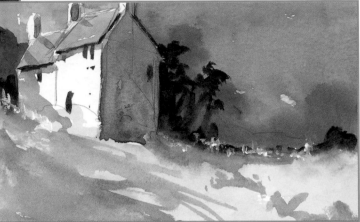

Figure 11 Light and shade patterns change constantly throughout the day, so it is not always a case of accepting what you see when you are looking at a subject. You could decide where the light is coming from instead. Here, the front of the house is in shadow and sunlight casts long shadows over the foreground.

Figure 12 This is the same painting, but see how the shadows are now stronger on the left of the picture. Notice how the sunlight catches the front of the house, whereas the side wall is now in the shade. In both pictures, the dark woods throw the house forward, emphasising the shape of the building.

Colour

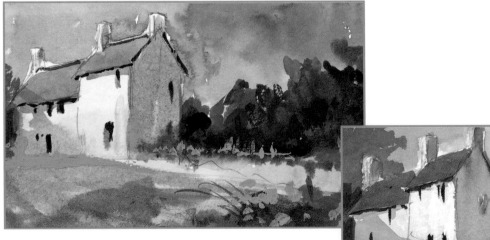

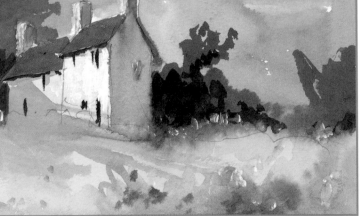

Figure 13 The choice of colours will have a significant bearing on the overall effect of your painting. Warm colours create a happy mood, whereas cool colours are less joyous. Here, warm reds, oranges and browns dominate the cooler colours.

Figure 14 Here, the same scene has a very different feel. The greens and whites are prominent against dark trees and a watery blue sky. The effect is more springlike and you can almost feel a cool chill in the air.

Intensity

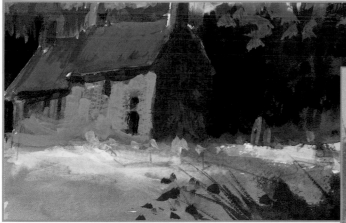

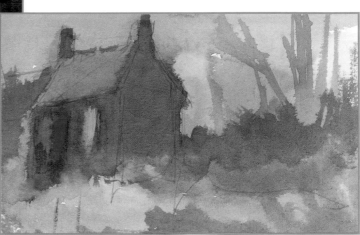

Figure 15 Intense colours add drama to any subject or scene. Placed against neutral colours, they greatly enhance a painting. Here the vibrant reds and oranges shine out against the cooler blues and greens. Strong, dark shadows complement the lighter areas.

Figure 16 Here, tones of grey create a cold, wintry feeling. The startling contrast of the glowing windows makes them look as if they have been painted with fluorescent colours. Even small amounts of intense colour can enhance a sombre scene.

Active/passive

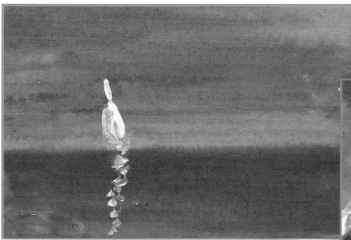

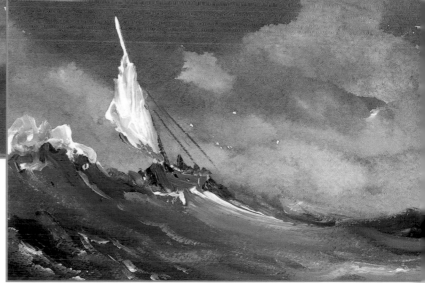

Figure 17 If you want to capture the feeling of a quiet, peaceful scene, use mainly horizontal and vertical lines. This will make the viewer's eye rest in one place. Here, a boat sails across a calm sea. It is a simple composition, yet it evokes a great sense of space and freedom. The mood is further enhanced by just using tones of blue, with vertical splashes of white indicating the boat and its reflection.

Figure 18 If you want to express vigour and energy in your paintings, introduce diagonal lines. The viewer's eye is immediately drawn into the action, or the mood. Here, a small sailing boat battles against the waves. Storm clouds threaten overhead and the whole feeling is one of drama and movement.

TIP
There are many more emotions you could consider expressing in your paintings, such as: happy, sad, angry, depressed, worried, hopeful, expectant, eager, chaotic, orderly or contemplative.

Composing from photographs

When painting on site there is often too much information, making it difficult to select a good composition. Nature is very rarely kind in arranging things in the right places and in the right sizes, colours and tones to help.

Even when using photographs, we have to be selective in what we choose for our composition. Below is a photograph I took just outside my village. On the face of it, it does not seem very interesting, because there is too much information in it. However, if we are selective, there are a number of little gems within it which can be turned into paintings. I have marked out three of these scenes and the results are shown in the paintings.

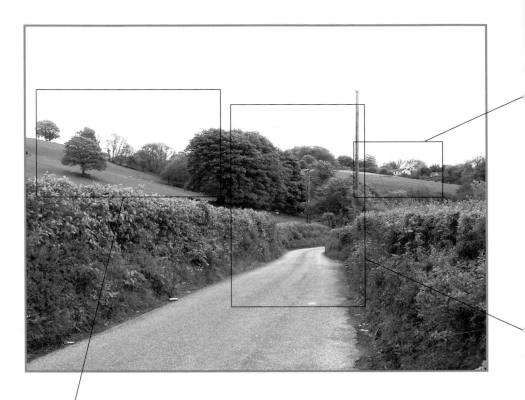

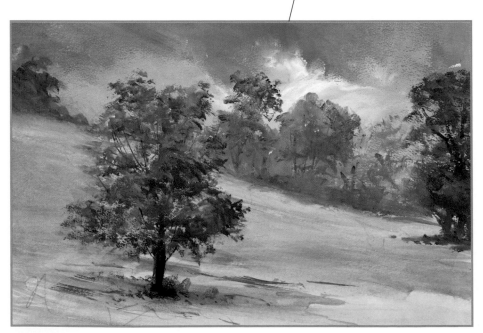

In this painting I have isolated the field on the left and made the tree the focal point. The background trees were painted with cool neutral colours to allow the foreground tree to dominate.

28

This farm was on the horizon to the right. Although I used a variety of greens in the background trees, I gave the right-hand farm building strong tonal contrasts to make it the focal point.

This is a section from the middle of the picture. I decided to make this a dominantly tonal painting where light and dark shapes are more prominent than colour. I added two figures for interest.

Misty Mountains

WATERCOLOUR TECHNIQUE

This first project involves painting a landscape using acrylics like watercolours. The paints were thinned with water.

Use the more transparent colours wherever possible to achieve the watercolour effect – check the tube details. This is because if acrylics are mixed without medium, they may not dry as pure as watercolours. Phthalo blue, used in this project, is an extremely transparent colour and retains its transparency and clarity when thinned with water.

If you have previously used watercolours, the first thing you will realise is that acrylics dry approximately the same colour as when wet, unlike watercolours, which dry to a lighter tone and intensity.

Make sure you have more than enough paint mixed so you do not run out of it half-way through a wash of colour.

I decided to make the cottages my focal point and kept the roofs warm in colour to enhance this effect. The surrounding hills and mountain shapes were designed to lead the eye of the viewer to the focal point.

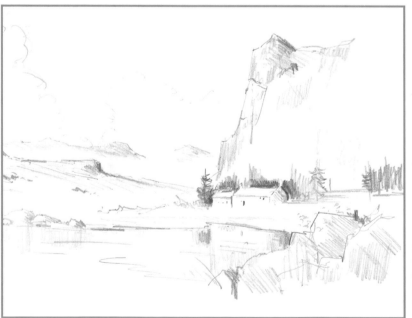

The original sketch highlighted the main players in the painting: the right-hand mountain and cottages and their placement within the scene. The composition ensures that all lines tend to lead the eye to the cottages.

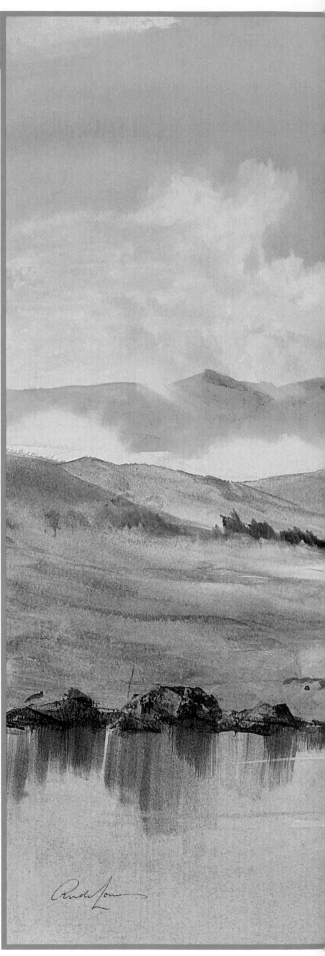

The finished painting.

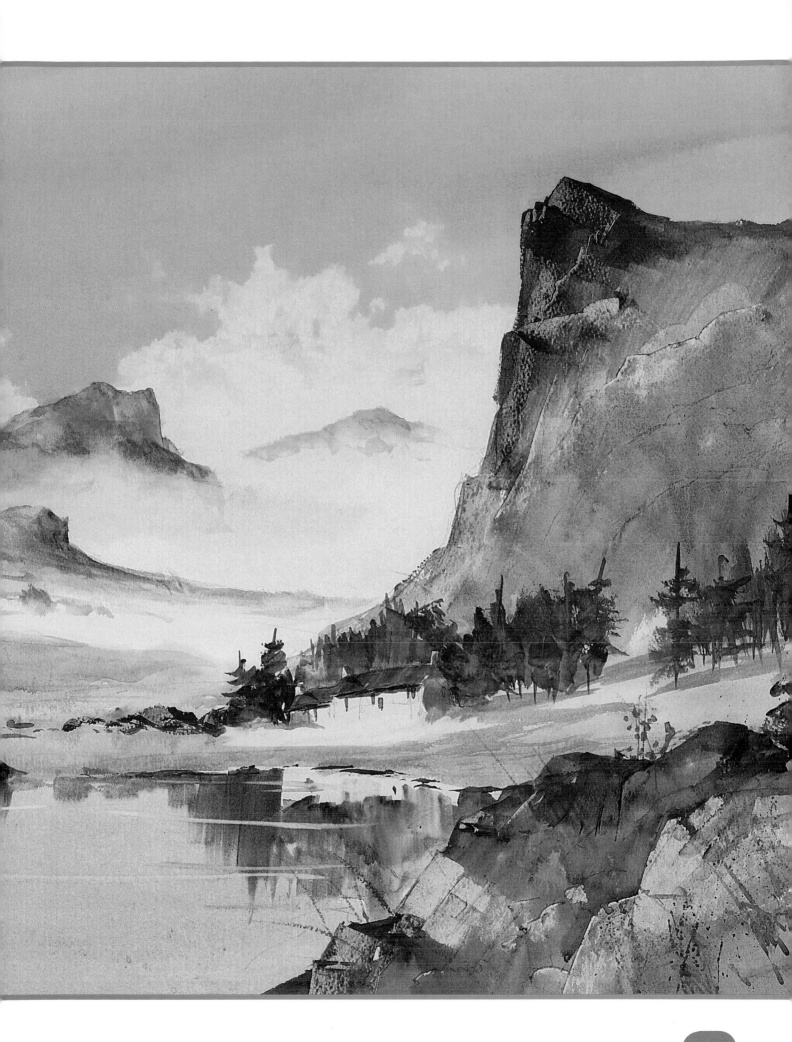

You will need

NOT 300gsm (140lb) watercolour
paper, 760 x 560mm (30 x 22in)
Colours
 phthalo blue
 cobalt blue
 ultramarine blue
 cadmium red light
 permanent rose
 yellow ochre
 lemon yellow
 cadmium yellow medium
 burnt umber
 burnt sienna
25mm (1in) flat brush
50mm (2in) flat brush
Kitchen paper
Razor blade

1. Referring to your pencil sketch (see page 30), transfer the basic outlines of the composition onto the paper. Mix a wash of phthalo blue, then use random strokes of the 50mm (2in) flat brush to lay in the sky area.

TIP

When painting a large wash area, paint it as you would paint a wall in your house: randomly in all directions. This evens out the brush strokes, giving a smoother, softer finish.

TIP

I paint on a near-vertical sheet of paper, so dribbles invariably break out from the beads of colour along the bottom edges of applied washes. Do not worry if they occur, simply mop them up with a piece of kitchen paper.

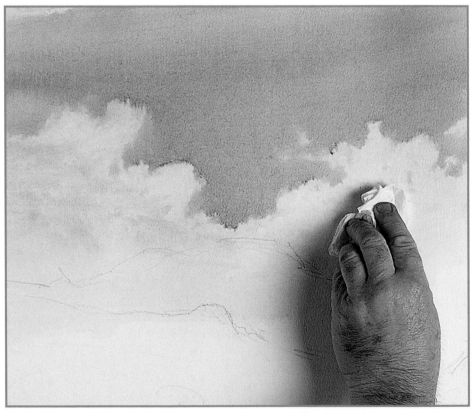

2. While the sky colour is still wet, use clean pieces of kitchen paper to lift colour off the paper to define the cloud formation.

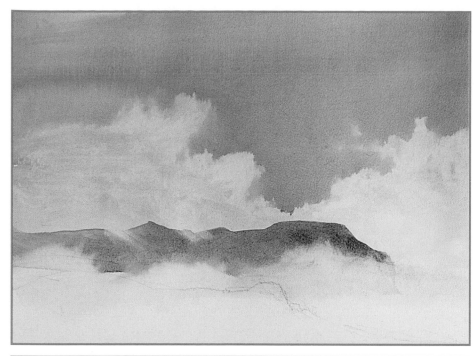

3. Mix a blue-grey from phthalo blue and cadmium red light, then use the 25mm (1in) brush to lay in the far distant mountains. Soften the bottom edges with kitchen paper. While the paint is still wet, use a clean, damp brush to pull some colour down from the top edge of the mountains to depict distant highlights.

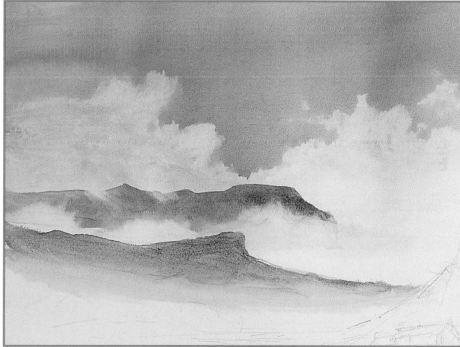

4. Mix touches of ultramarine with yellow ochre, then lay in hills in the middle distance. Add touches of lemon yellow on the lower, nearer slopes, then soften the bottom edges with a piece of kitchen paper.

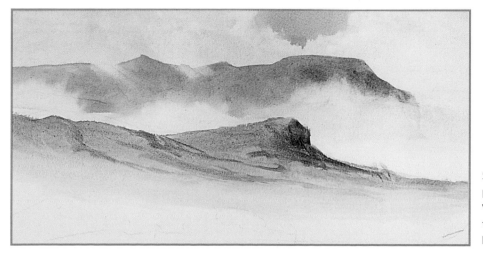

5. Use ultramarine with a tiny touch of permanent rose to define areas of shadow. Weaken this mix with more water, then use this to suggest the shapes of fields on the lower slopes.

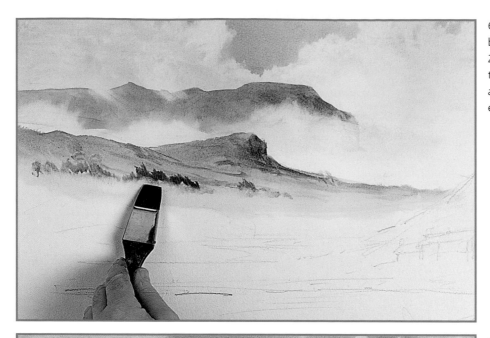

6. Mix a dark green from phthalo blue and burnt umber, then use the corner of the 25mm (1in) brush to make irregular marks to denote foliage in front of the hills. Use a clean, damp brush to soften the bottom edges of these marks.

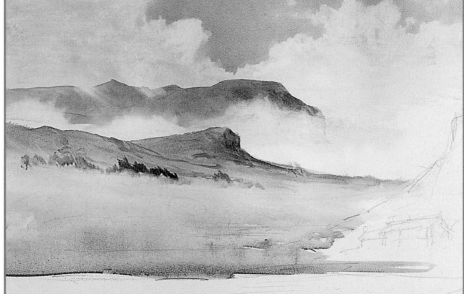

7. Use a lemon yellow wash to lay in the middle distance ground beyond the water. Introduce yellow ochre, wet in wet, followed by burnt sienna. Notice how depth in this area is accentuated by using cool tones at the top and warmer ones nearer the foreground.

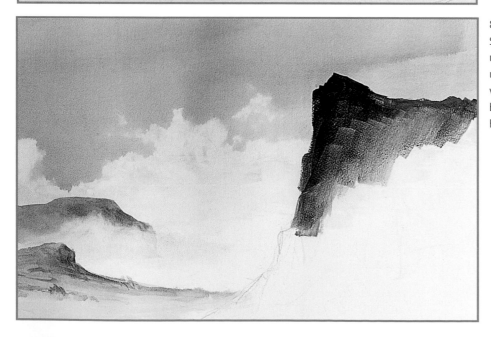

8. Now paint in the right-hand mountain. Start by defining the top edges with ultramarine mixed with a touch of burnt umber, then weaken the colours as you work across to the right. Add touches of burnt sienna and yellow ochre at the right-hand side.

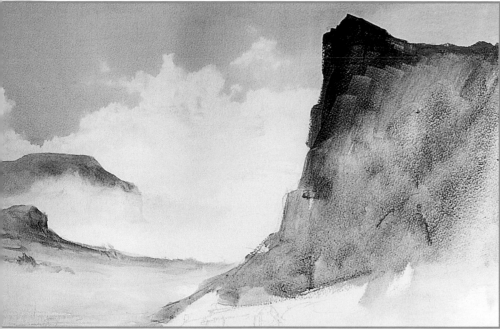

9. Working quickly while the previous colours are still wet, lay in patches of permanent rose, cadmium red light, ultramarine and burnt umber down the slope of the mountain to the back of the buildings. Allow the colours to mingle and create soft edges.

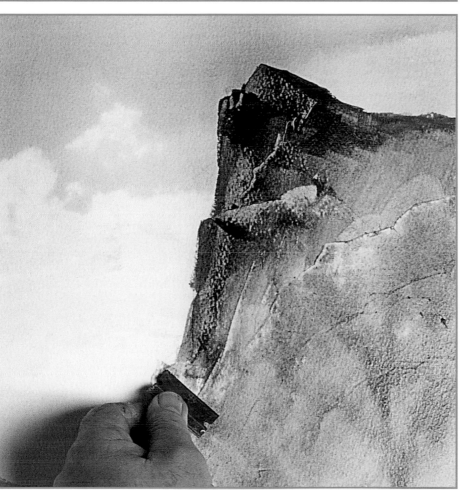

10. While the colours are still damp, use the razor blade to scrape colour off the surface to define the texture and shape of the rocks.

TIP
Keep the straight edge of the blade in contact with the paper. Make random shapes - some large, some small - and vary the angle of attack.

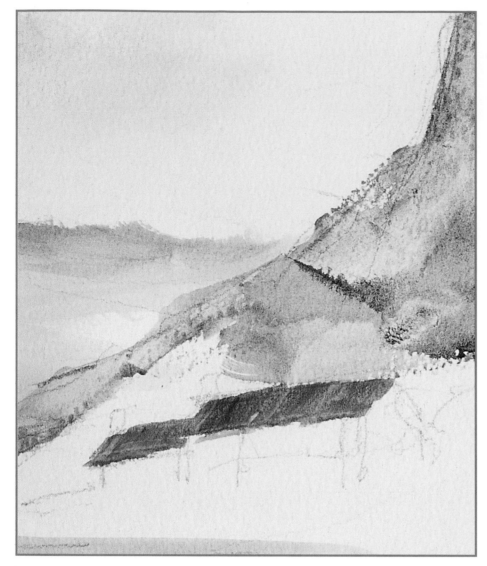

11. Still using the 25mm (1in) brush, block in the roofs of the buildings with cadmium yellow. Cover this with cadmium red light and allow the colours to mingle and vibrate.

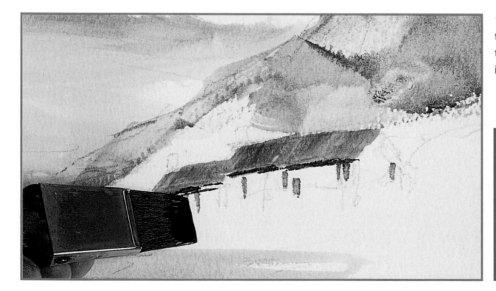

12. Mix a dark grey from the palette to add shadows under the eaves. Use the corner of the brush to paint in an indication of windows.

TIP
When painting buildings in a landscape, small, dark, vertical marks made with the corner of a flat brush will suffice to tell the eye that they are windows.

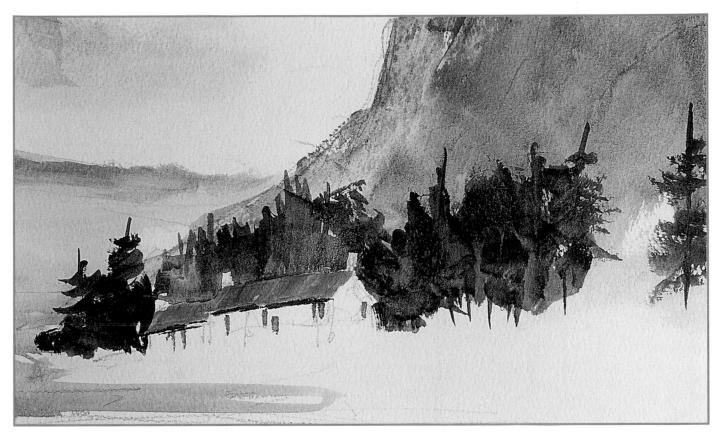

13. Use a mix of burnt umber and phthalo blue and the corner of the brush to develop the foliage behind the house. Use the flat of the brush to paint round the shape of the house. Vary the tones to create shape and form.

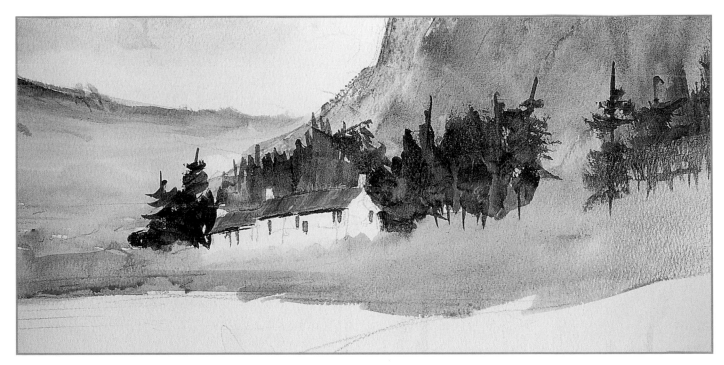

14. Block in the ground in front of the house with weak washes of lemon yellow, yellow ochre and burnt sienna; soften the top edge in front of the house with a damp brush. Leave to dry.

TIP
Remember, rocks do not look
real if they are all the same size.

15. Paint rocky shapes on the distant bank with tones of burnt sienna and ultramarine, wet on dry, then use the razor blade to develop texture and form.

16. Mix a weak wash of cobalt blue and a touch of permanent rose, then block in the shadowed end of the building. Use the same mix to glaze cast shadows across the ground in front of the building and under the trees.

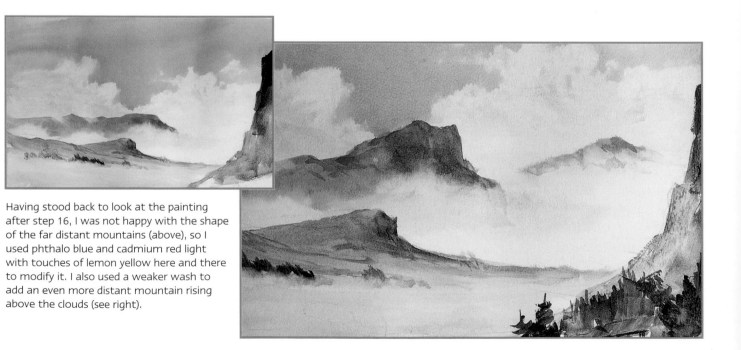

Having stood back to look at the painting after step 16, I was not happy with the shape of the far distant mountains (above), so I used phthalo blue and cadmium red light with touches of lemon yellow here and there to modify it. I also used a weaker wash to add an even more distant mountain rising above the clouds (see right).

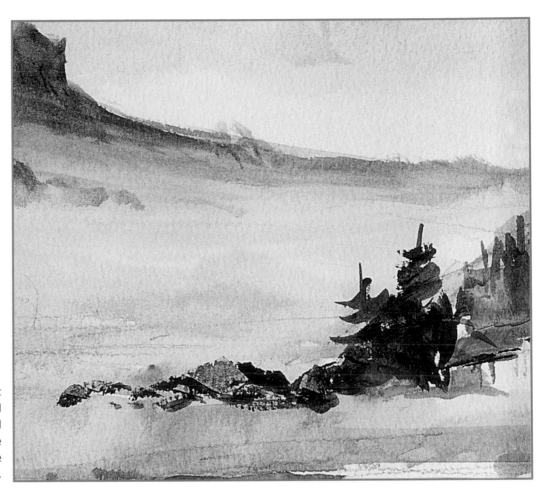

17. Use a dark mix of burnt sienna and ultramarine to add some rocks at the left-hand side of the buildings, then use the razor blade to add texture to them.

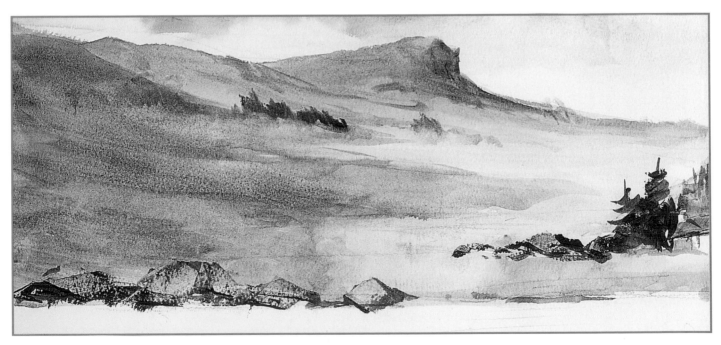

18. Use cobalt blue and permanent rose to make a shadow colour, then lay in a cast shadow across the middle distant ground beyond the water. Soften the bottom edges with water and a clean brush.

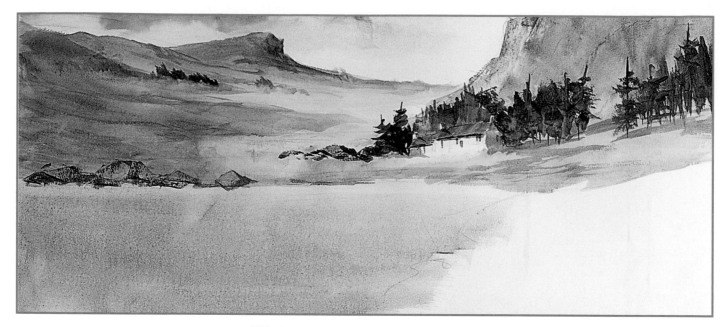

19. Wet the area of water then lay in a wash of phthalo blue to match the sky colour.

20. Using a clean, damp brush, pull down vertical strokes to form the reflections of the white walls of the buildings.

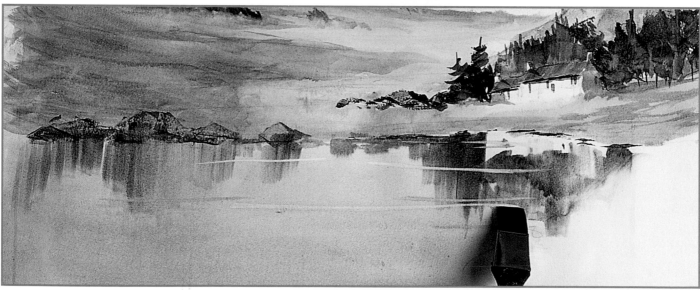

21. While the water area is still wet, use the colours on the palette to lay in reflections of the roofs, trees and rocks. Soften the edge where the foreground rocky area meets the water. Drag a clean, dry brush horizontally through the reflections to define ripples.

22. Now work on the warm, rocky foreground. Lay in random strokes of burnt sienna, permanent rose, burnt umber and cadmium red light, wet in wet, and allow the colours to mingle.

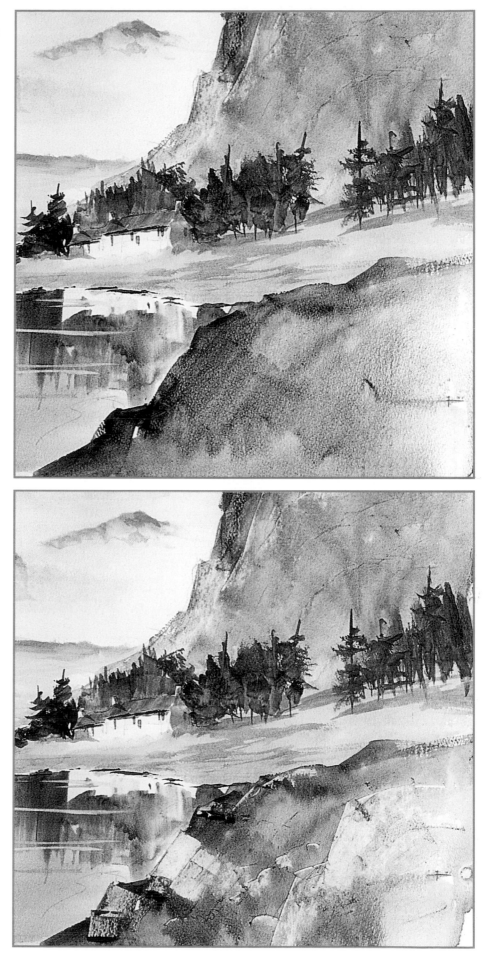

23. While the colours are still wet, use the razor blade to define the shapes of rocks. Vary the size and angle of each stroke with the razor blade to create a natural look.

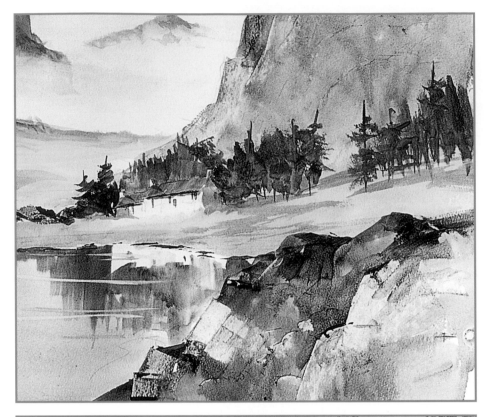

24. Use the darks on the palette to develop the shape and form of the rocks by working up areas of shadow. Make the darkest marks at the top to lift it away from the grassy ground behind the rocks.

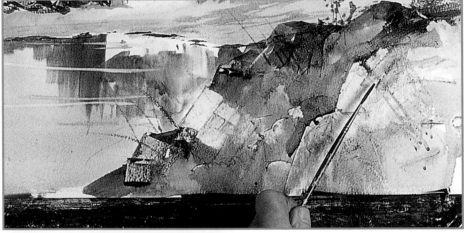

25. Make loose flicks with the rigger brush to add some spiky grasses.

26. Now use a rolling action with the side of a dry brush to create sparkling, textured foliage on top of the rocks.

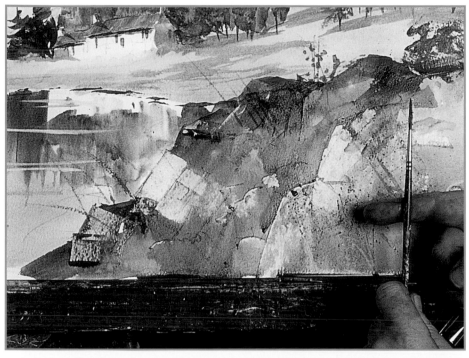

27. Finally, tap a loaded brush against your finger to spatter small speckles of darks here and there over the rocks.

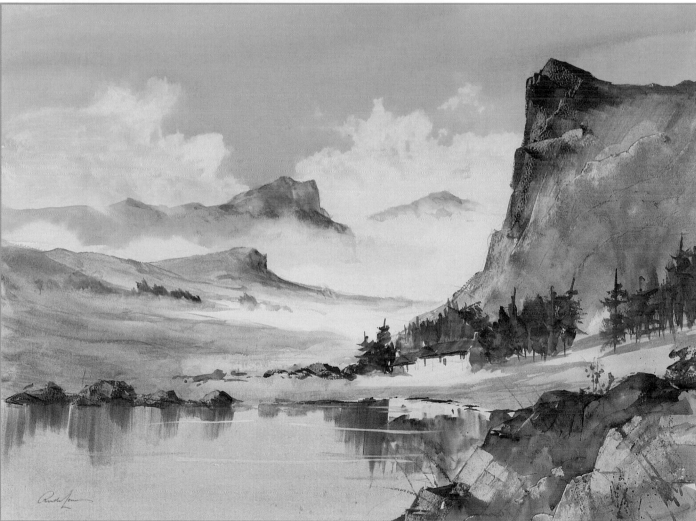

28. Having stood back to look at the painting at the end of step 27, I decided to extend the rocky outcrops at the left-hand side of the house and to re-emphasise the rocks on the far shoreline.

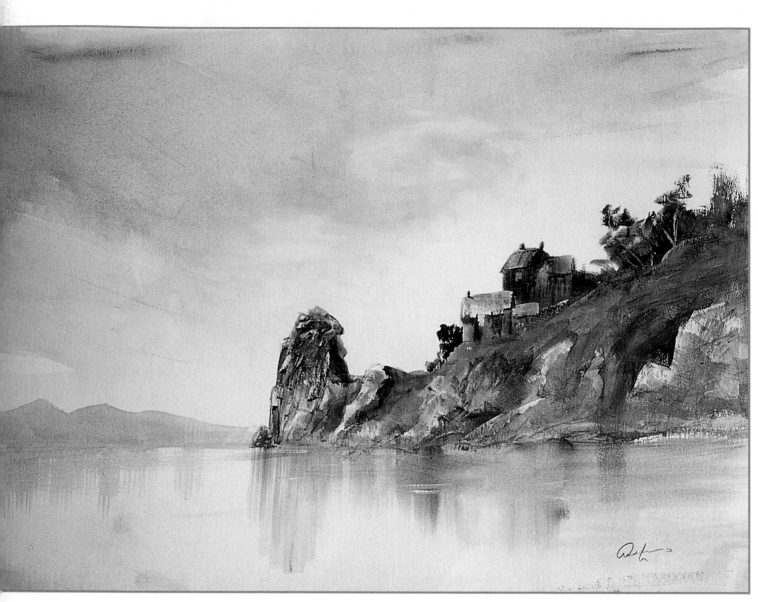

Hillcrest

760 x 560mm (30 x 22in)

This was painted mainly in watercolour techniques, painting thinly to ensure luminosity in the sky and water. Although the land area was painted a bit more strongly, with the highlights scraped out with a razor blade, I managed to achieve a luminous effect in this area too.

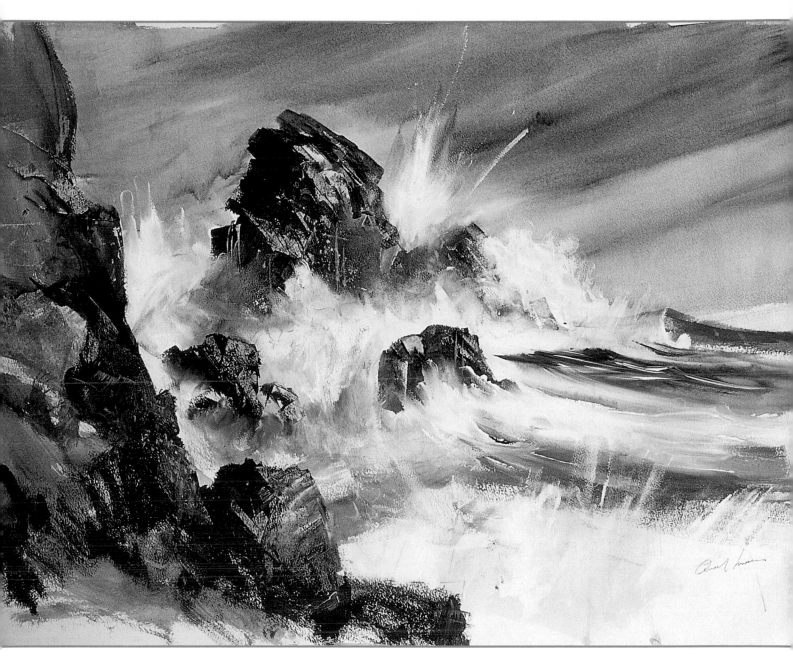

Llangrannog Storm

760 x 50mm (30 x 22in)

The sky was produced on watercolour paper by painting some colours into the top right of the picture, tipping it vertically and at forty-five degrees and then spraying it with a fine mist of water. Eventually the paint started the run diagonally across the paper. I dried it with a hairdryer when I was satisfied and then straightened up the painting again. The streaks then showed as rain pouring at forty-five degrees across the sky. The rest of the painting was done opaquely using techniques more associated with oil painting.

Seascape

OIL TECHNIQUE: IMPASTO

Impasto is the oil painting technique that uses the buttery thickness of the paint to create texture. The paint is applied thickly and the brush strokes or marks of the painting knife are left visible. You can also achieve this technique using acrylic paints, leaving them undiluted.

For this project, I wanted to capture the dramatic atmosphere of a seascape. I chose the impasto technique because the application of paint by painting knives and fingers gives a feeling of powerful movement and textures. Detail does not help in achieving drama in a painting, and using painting knives prevents you from getting too detailed in your approach. It is also a lot of fun.

I used a canvas board to help me in achieving a textured finish. A traditional canvas could be used but canvas boards are cheaper, lighter and more convenient for my purposes.

This scene is purely imaginary but is based on many similar scenes I have visited along the Welsh coast. I wanted to show the power and movement of the sea so I used a lot of diagonal shapes to suggest this vigour. The rock in the top right with the grassy top was my focal point so everything was geared to driving the viewer's eye in this direction. Mood, rather than detail, was my priority.

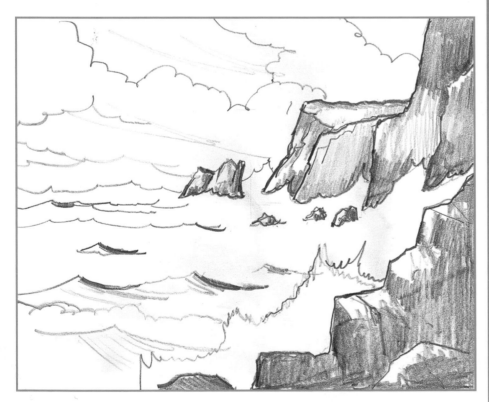

The silhouettes of the headland play a big part in this composition, together with the diagonal thrust of the seas and sky. Detail was not required as the painterly quality would set the scene.

The finished painting.

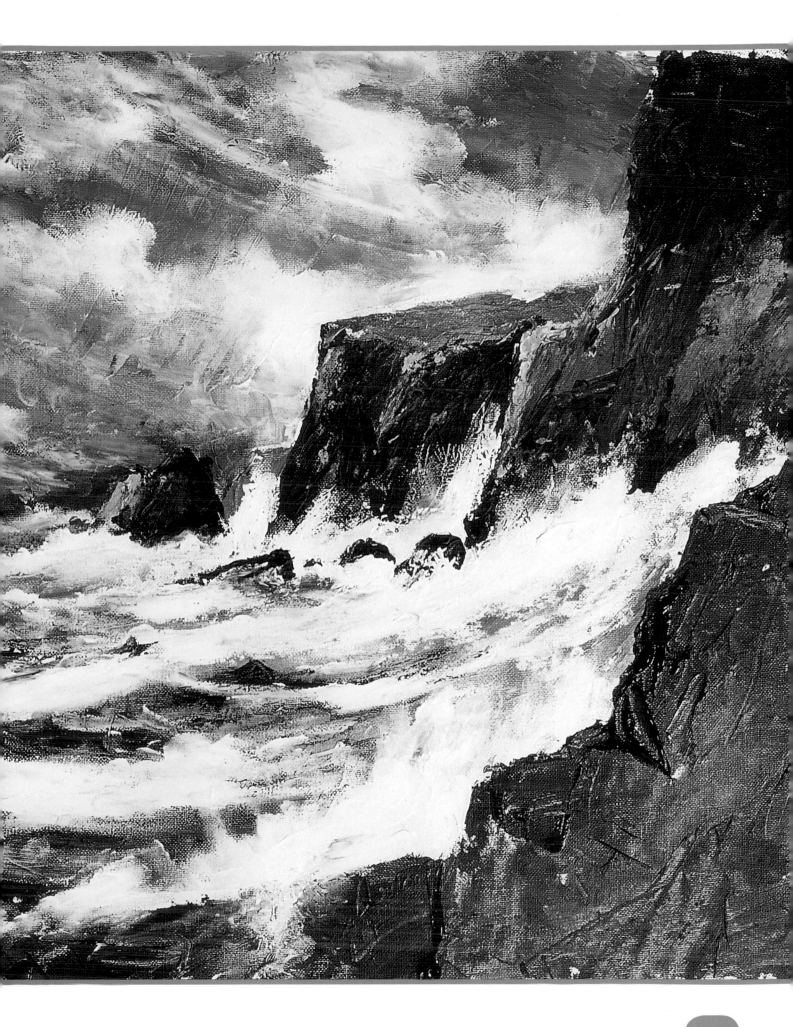

1. Transfer the basic outlines of the composition onto the canvas board, then block in the rock in the centre of the composition with a mix of ultramarine, burnt umber and a touch of titanium white. Drag the painting knife across the surface of the canvas board.

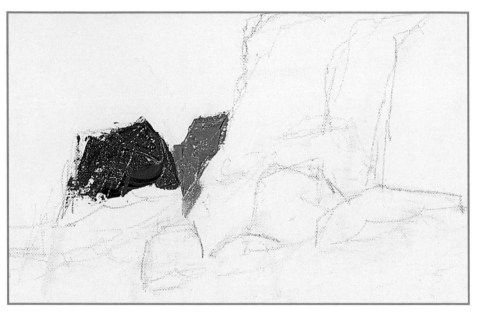

2. Add a touch more white to the mix, then block in the next rock to the right.

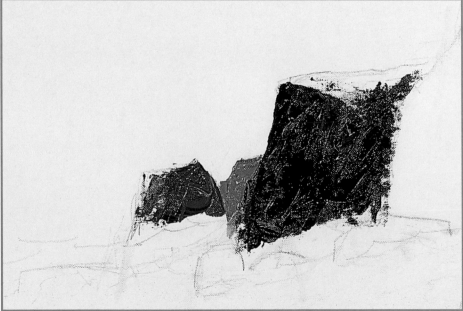

3. Working towards the right, block in the next rocky area using darks mixed from ultramarine and cadmium red light. Introduce touches of cadmium yellow, more cadmium red light and more ultramarine, then use the knife to mix colours and create texture.

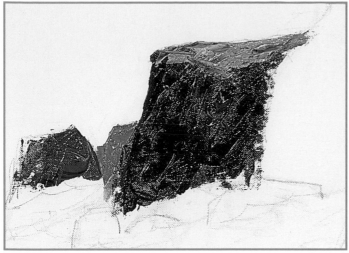

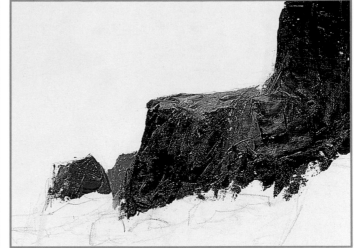

4. Block in the grassy area on top of the rocks with greens mixed from cadmium yellow and ultramarine.

5. Now work up the last of the background rocks. Start at the top, using darks mixed from ultramarine and burnt umber, then introduce some cadmium orange and yellow ochre. Emphasise the base of these rocks with more of the dark mix with touches of cadmium red light here and there.

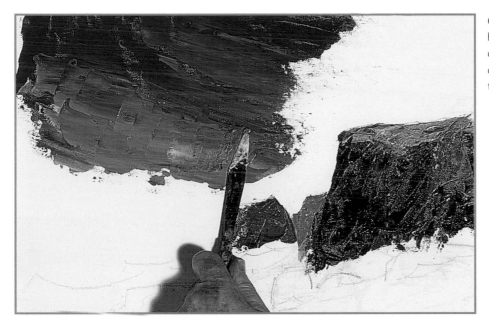

6. Start painting the sky with cobalt blue. Working from the top left of the composition, spread the paint smoothly down and across the board. Introduce some titanium white in the lower sky.

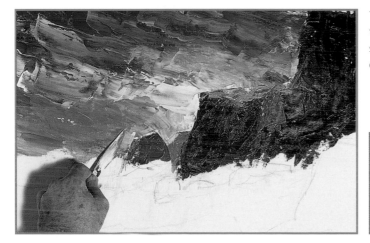

7. Work up the whole sky, adding more titanium white here and there and developing the marks to suggest a windy day. Where the sky meets the rocks, work the knife strokes right to left from the edge of the rocks back into the sky.

TIP
Diagonal strokes and shapes give movement and drama to a scene. Placid scenes are usually achieved by using mainly horizontal and vertical shapes.

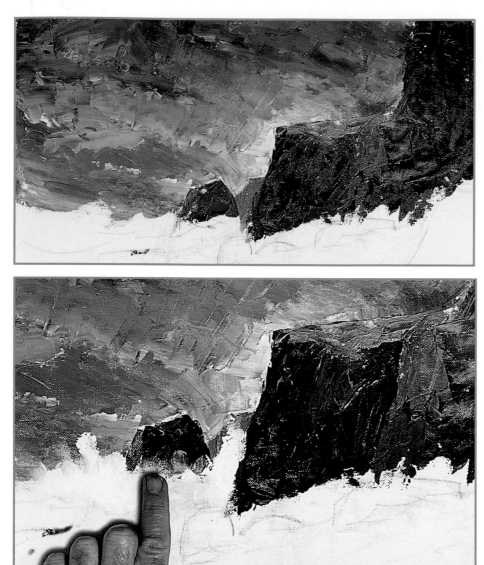

8. Working with the knife quite flat on the surface, go back over the sky and smooth out some of the previous marks.

9. Redefine the small rock in the centre of the composition and the larger rocky area to its right with darks mixed from ultramarine and cadmium red light, then leave the painting to dry. Start to create the foaming water below the rocks by picking up some titanium white on your finger and scumbling it up onto the central rock and into the sky area on either side. As the paint starts to dry, flick your finger upwards to suggest spray crashing against the rocks.

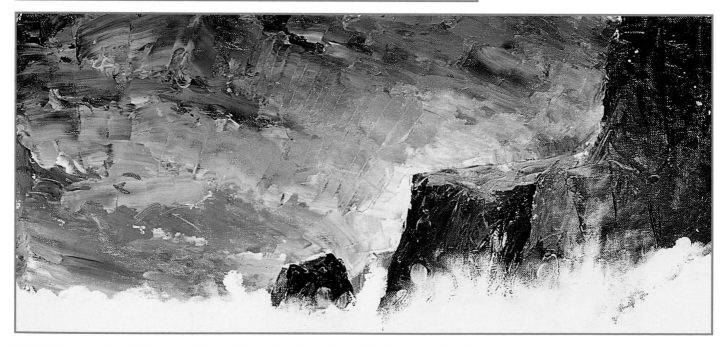

10. Work across the painting, scumbling white up into the rocks and the bottom of the sky.

11. Still working with your fingers and titanium white, scumble in the clouds.

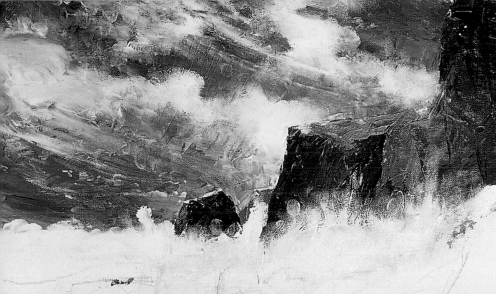

12. Continue to develop the fluffy clouds, then give them a windswept feel by introducing some diagonal streaks made by wiping your finger across the board.

13. Now work on the water. Lay in the first wave using a mix of cobalt blue and titanium white; work the knife from the top of a wave down to the left, then from the top down to the right.

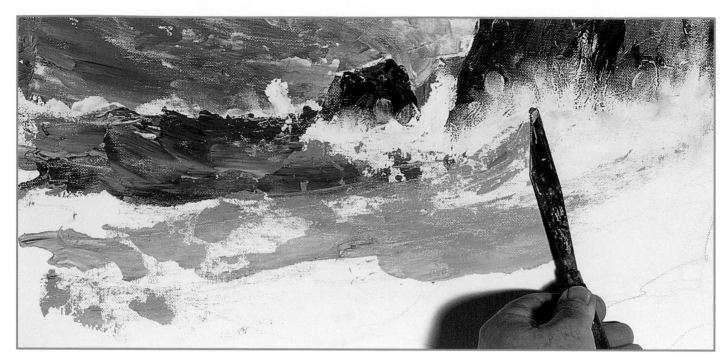

14. Continue to build up a lively set of waves using different tones of cobalt blue. At the right-hand side, keep the knife flat and lift it off when it is clear of paint. Lifting the painting knife off wet impasto gives the mottled effect I wished to achieve in this area.

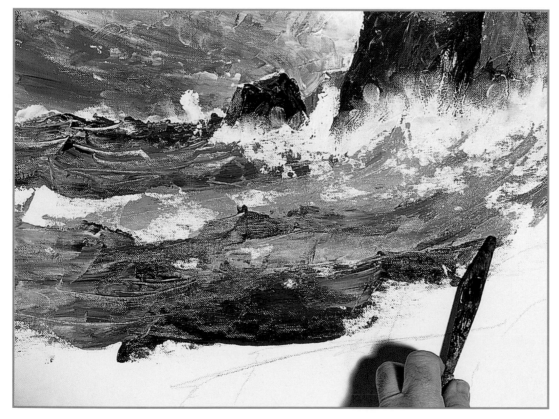

15. Use mixes of ultramarine and cadmium red light to lay in some darker blue in the foreground. Keep the knife strokes lively to indicate strong movement of the waves. Introduce some smaller marks of these darker tones to the background waves.

16. Mix dark tones from ultramarine and cadmium red light, then drag these down into the foam of the waves crashing against the rocks. At the same time, develop areas of shadow on the rocks. Leave the painting to dry.

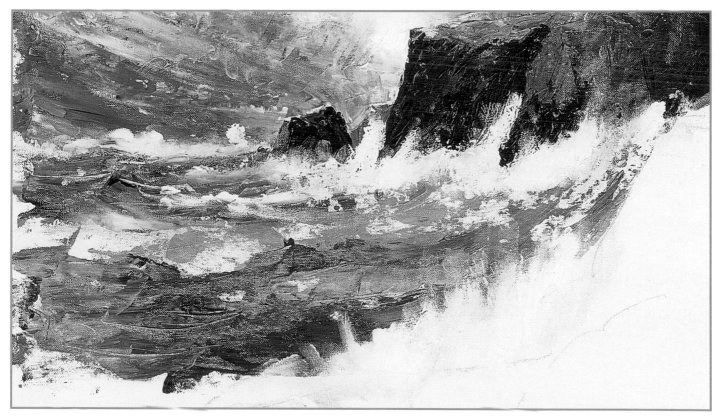

17. Using titanium white and your finger, scumble the paint across the bottom of the large group of rocks to redefine the spray. Scumble more white along the horizon to suggest distant rock formations, then work up lots of spray in the foreground.

18. Use a near-black mix of burnt umber and ultramarine to lay in some smaller rocks among the spray; remembering to keep the shapes irregular and the sizes different.

19. Finger scumble some spray in front of these new rocks, then add some frothy white spume on the surface of the waves in front of them.

20. Use mixes of titanium white and yellow ochre to work up highlights on the top and left-hand edges of the rocks. Add touches of light blue permanent and titanium white to the faces of the rocks with touches of cadmium red light to create an interesting set of tones and shapes.

21. Having stood back to look at the painting, I decided that the small rock in the centre of the composition was merging with the sky. To overcome this problem, I applied stronger tones of cobalt blue in the sky immediately behind the rock.

22. Develop the texture of the grassy area on top of the rocks with greens mixed from yellow ochre and light blue permanent. Rework the cloud formation behind the grass to lift the top of the rocks away from the sky.

23. Block in the foreground rocks with a medley of warm colours: cadmium orange, yellow ochre, permanent rose and burnt sienna. Add touches of cobalt blue to create cooler areas.

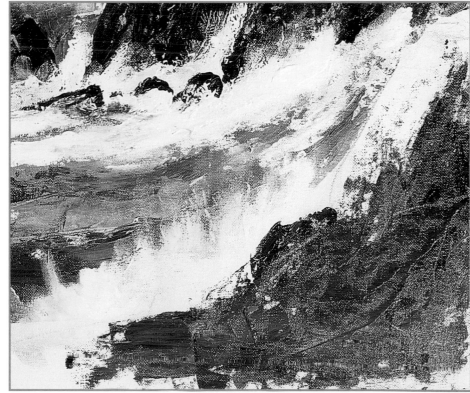

TIP
Warm colours and strong counterchange (light against dark) help to make the foreground appear closer and the headland further away.

24. Darken the top edges of the rocks with mixes of ultramarine and burnt sienna. Use the edge of the knife as you would a razor blade (see step 10 on page 35) to move the colours around, creating texture, highlights and shadows.

25. We now need to warm up the foreground area of the sea to make it look much closer. First, develop the wave structure with ultramarine with added touches of cadmium red light.

26. Then scumble titanium white with your finger to add the spray and spume.

27. Complete the foreground by scumbling touches of titanium white spume over the top edges of the rocks.

28. Finally, use a rigger brush to introduce touches of cadmium orange, yellow ochre and cadmium red light to the small, distant rock with which we started this demonstration. This should act as a stepping stone to the focal point – the larger, grass-topped rock to the right. Then use the darks on the palette to accentuate the bottom of the rock.

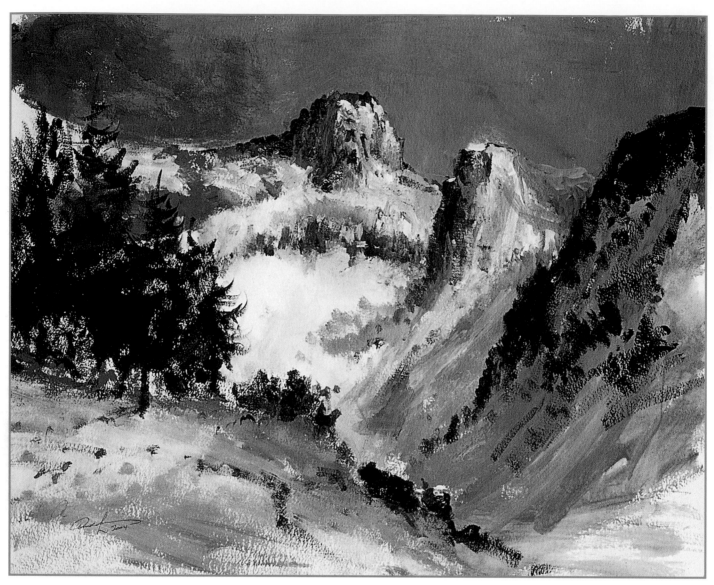

Winter Wonderland

560 x 430mm (22 x 17in)

This was painted almost completely using a painting knife – and was great fun to do. The shapes of light and shadow created in this way play a big part in the composition. The deep blue sky emphasises the lit snow.

Opposite

Gondola Repair Yards, Venice

540 x 650mm (21¼ x 25½in)

There were no gondolas being repaired that day! The view is looking north towards the Grand Canal behind the rear buildings. I applied the paint thickly with both painting knives and brushes, ensuring there were some big tonal value changes between light and dark, to establish the power of the sunlight. The shadows were glazed on using a mixture of cobalt blue with a tinge of permanent rose and some gloss medium and varnish with a little water. This created great luminosity in the shadows.

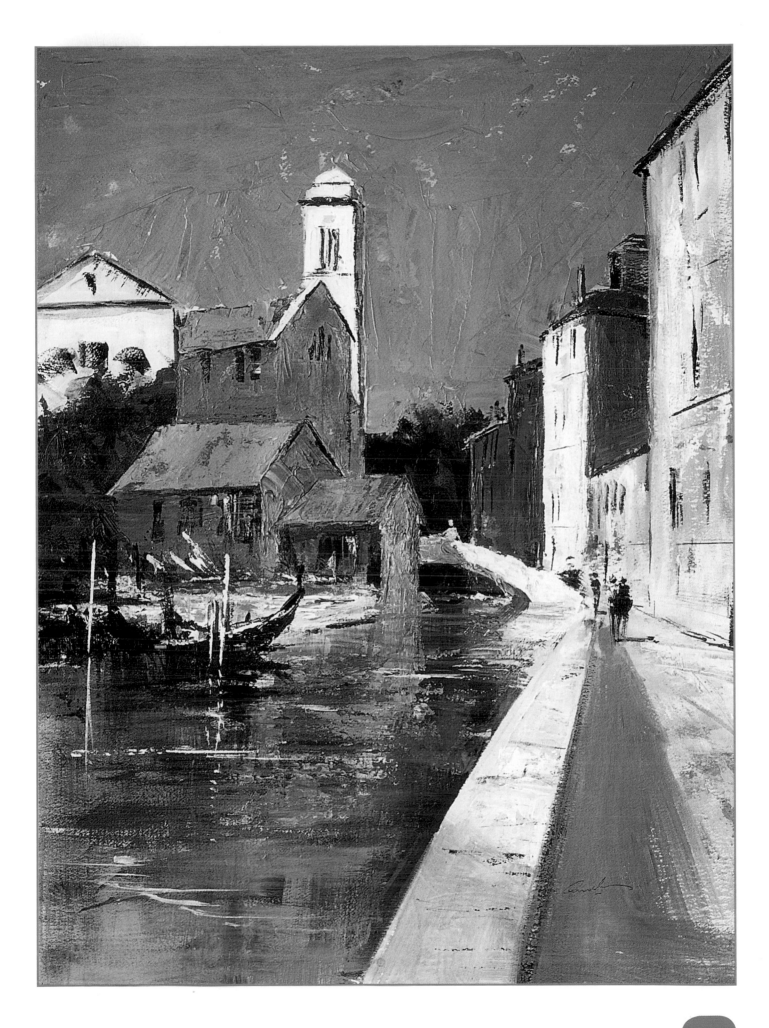

The Grand Canal, Venice

MIXED TECHNIQUES: THICK AND THIN

In this project I have used acrylics with both watercolour techniques and the impasto oil technique in which the paint is used thickly.

I wanted to paint the Grand Canal in Venice to accentuate the atmosphere of early morning. To do this I used colour and tonal relationships rather than a detailed rendering of the scene. If I had painted every window and statue on the Santa Maria De La Salute building in the distance, it would seriously have distracted the viewer from the atmosphere I wanted to achieve.

Warm colours in the foreground and cool in the background add a feeling of distance.

Here we have two different applications of acrylics. Phthalo blue is applied transparently (above) as in watercolours and (right) dark mixes have been applied opaquely as in oil painting.

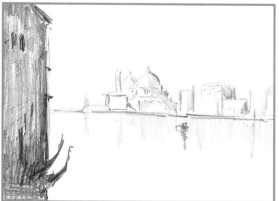

I wanted to show the difference in size between each side of the Grand Canal. I added contrasts in colour and tonal value to accentuate this effect.

The finished painting.

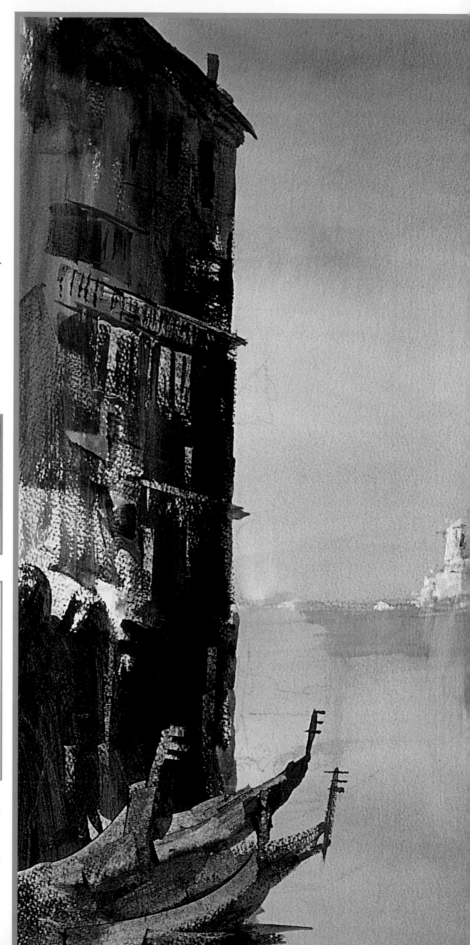

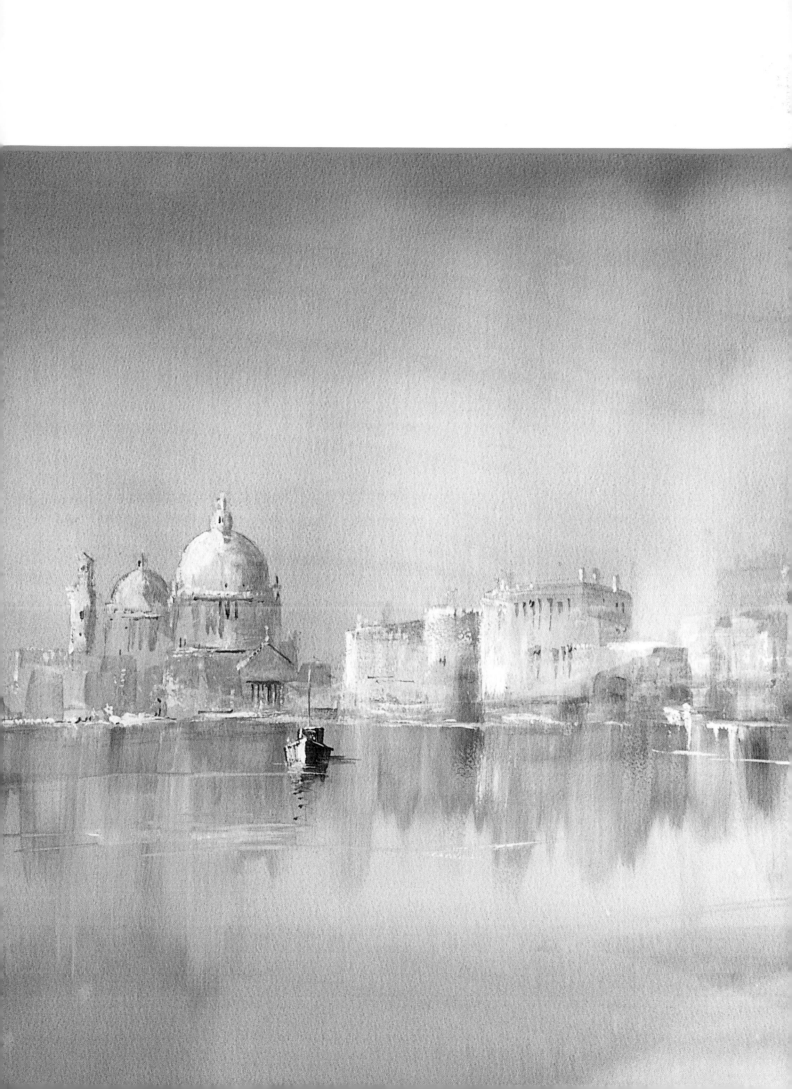

NOT 300gsm (140lb) watercolour paper,
760 x 560mm (30 x 22in)
Colours:
 phthalo blue
 cobalt blue
 ultramarine blue
 cadmium red light
 permanent rose
 yellow ochre
 burnt sienna
 burnt umber
 titanium white
Soft pencil
25mm (1in) flat brush
50mm (2in) flat brush
No. 3 rigger brush
Razor blade

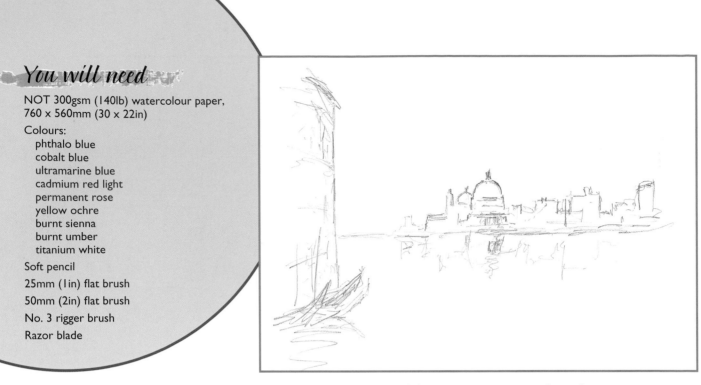

1. Sketch the basic outlines of the composition using a soft pencil.

2. I wanted a transparent sky to contrast with the opaque painting to follow, so I used phthalo blue for its transparency, thinned down with water, giving this area a watercolour feel. Prepare a wash of phthalo blue, sufficient to cover all the sky area. Wet the sky area with clean water, then, using bold, random strokes of the 50mm (2in) flat brush, block in the sky, taking the colour across into the buildings at the left-hand side of the composition.

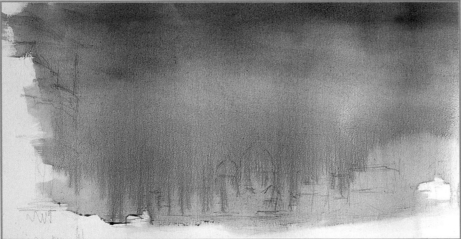

TIP
The colour of the sky changes from a purply blue high up to a more greeny blue lower down, also becoming paler near the horizon. Next time you look at a clear sky with some clouds, observe the difference in blues between the top and bottom of each cloud.

3. Add a touch of cadmium red light to the phthalo blue, then use this mix to strengthen the top part of the sky.

4. While the sky is still wet, use a razor blade to scrape away the blue sky colour to create highlights on the buildings, then leave the painting to dry.

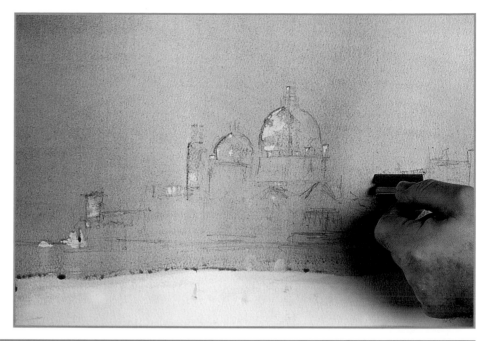

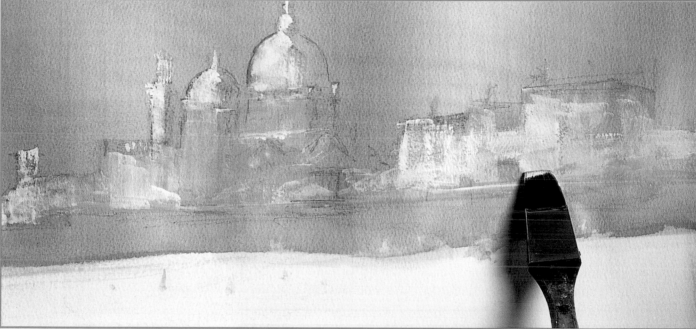

5. Here we begin to paint opaquely, as with oils. Use neat titanium white on a damp 25mm (1in) flat brush to accentuate the sunlit shapes on the buildings.

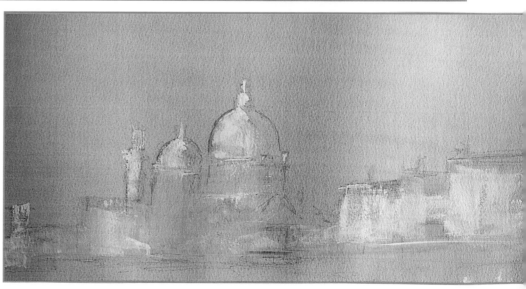

6. Add a touch of yellow ochre to warm up the titanium white slightly, then begin to develop the shape and form of the buildings. Remember that these are distant buildings, so you do not need too much detail.

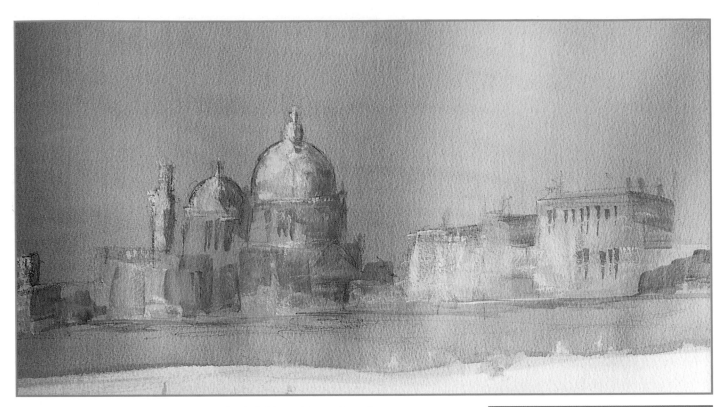

7. Now mix a shadow colour – here I used cobalt blue with touches of permanent rose and titanium white – and start to develop the shadowed parts of the buildings.

TIP
Never make an object exactly half shadowed and half sunlit. Either light or shade should always predominate.

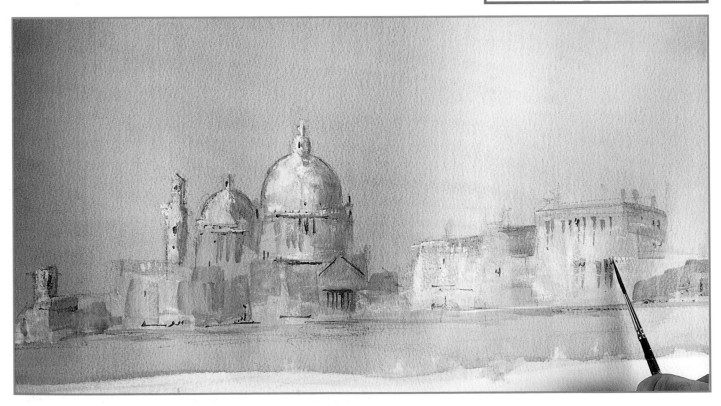

8. Prepare a darker shadow colour using ultramarine and cadmium red light, then use the rigger brush to add small details. These should not be too structured, just enough to suggest shape and form.

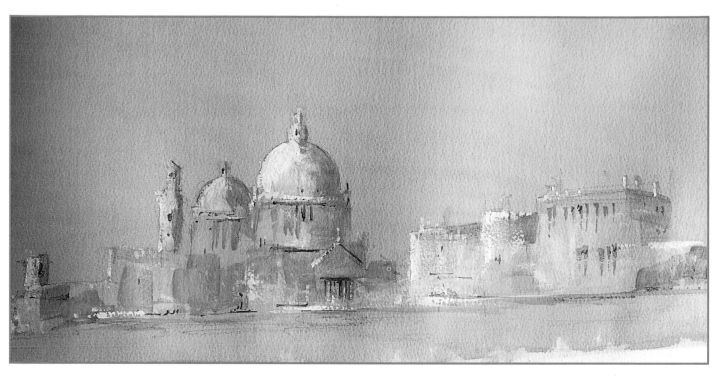

9. Now use the rigger brush and neat titanium white to re-emphasise the brightest parts of the sunlit areas.

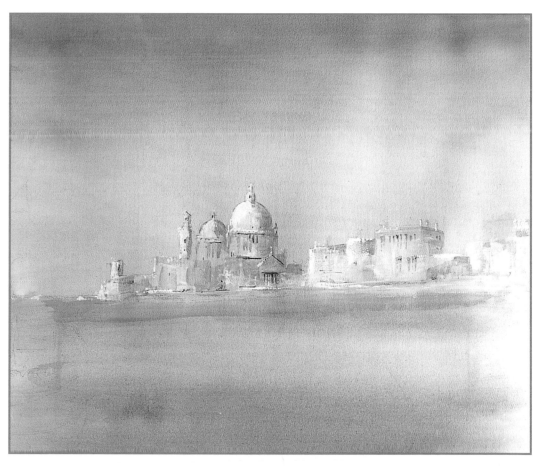

10. Using the 50mm (2in) flat brush, wet the foreground area, then block it in with the sky colours: phthalo blue greyed with a touch of cadmium red light at the bottom to reflect the darker top of the sky.

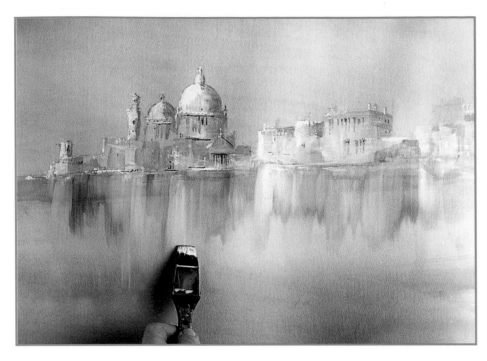

11. While the foreground water area is still wet, use a damp brush with titanium white and the shadow colours to pull the reflections of the buildings down into the water. Working quickly while the paper is still damp will help give soft edges to the reflections.

TIP
The water is not perfectly flat but consists of a series of ripples. Objects reflect off each ripple, making the reflections appear to lengthen. A single light seen across a lake is often seen as a band of light for the same reason.

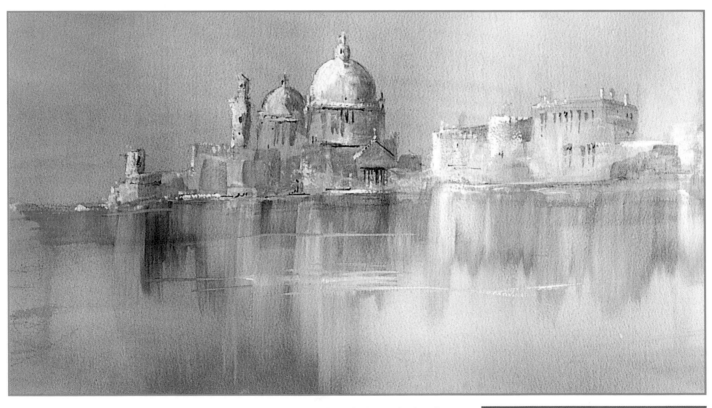

12. Pick up a touch of neat titanium white on a damp brush, then, holding the brush almost upright, drag it horizontally through the vertical reflections to suggest ripples in the surface of the water. These must be placed randomly, but do not make too many. Leave the painting to dry.

TIP
Evenly spaced ripples look like tram lines, so space them randomly for a natural look.

13. Now begin to work on the buildings on the left-hand side of the painting using oil techniques, with thicker paint. Use the 25mm (1in) flat brush with a dark blue mix of ultramarine and burnt umber to start blocking in the top of the building. Cool, blue tones at the top of any building suggest height.

14. Now begin to work down the wall, adding burnt sienna into the bluish mix.

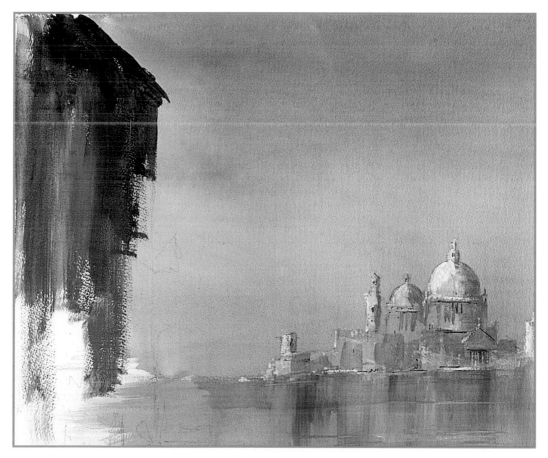

15. Continue down the wall, working yellow ochre and permanent rose into the brown. Keep changing colours and the direction of the brush strokes.

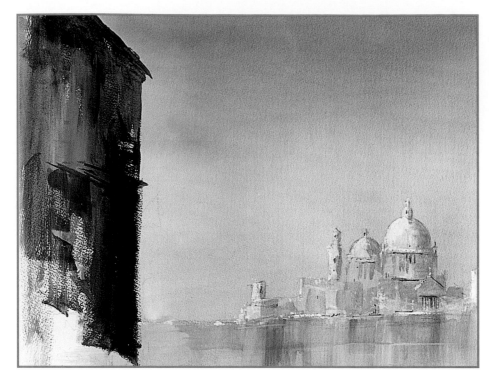

16. Use the dark blue mix of ultramarine and burnt umber to define the edge of building and to start the suggestion of a balcony on the top floor of the building.

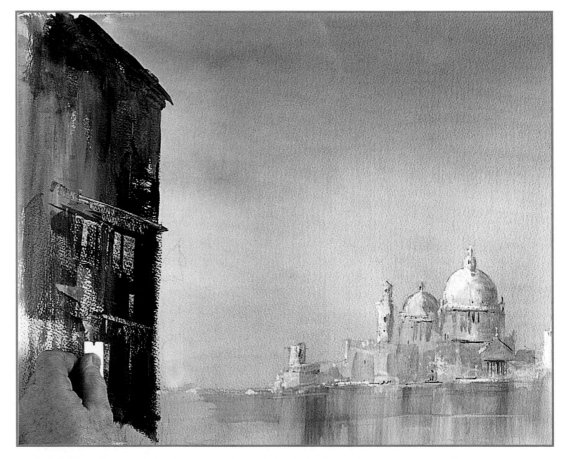

17. While the colours are still damp, use the razor blade to drag colour across the surface of the paper to suggest windows and highlights.

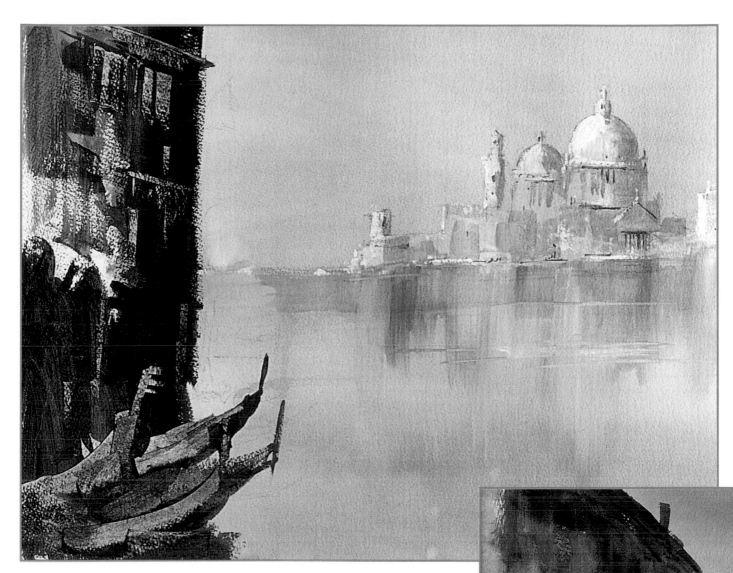

18. Using a dark mix of burnt sienna and ultramarine, add darks at the bottom of the building. Use the same colour to define the stern posts on one or two gondolas, then drag the razor blade through the darks to suggest the shapes of the boats' hulls.

19. Use the same dark to sharpen the right-hand edge of the building and to indicate windows on the top floor. Add more marks to define the balcony and to suggest windows on the lower floors.

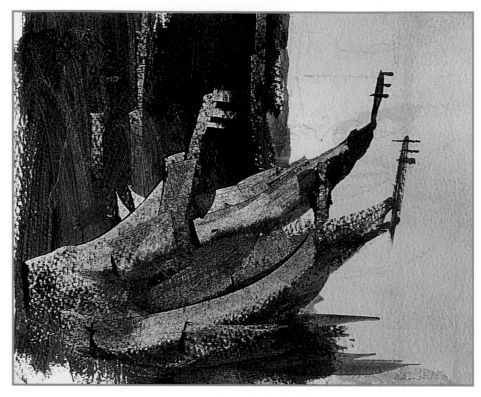

20. Use the same dark colour to add details to the gondolas.

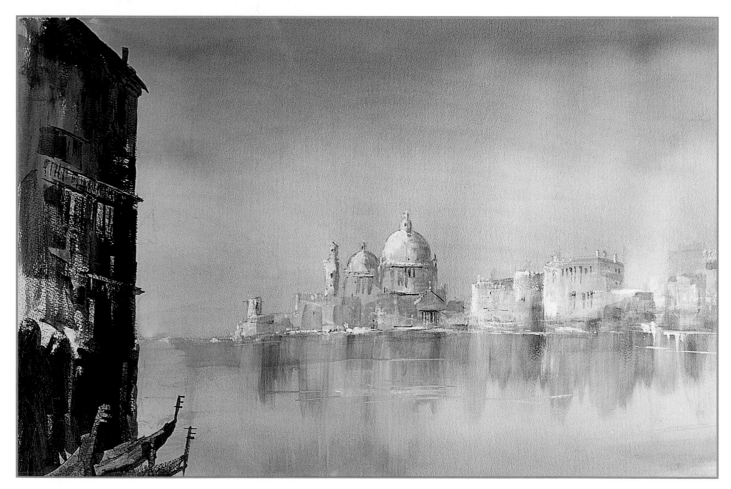

21. Having stood back to look at the composition at the end of step 20, I realised that the right-hand side of the distant shore line was too high. Using the colours mentioned in steps 6–9, I amended the shapes of the buildings in this area and redefined their reflections.

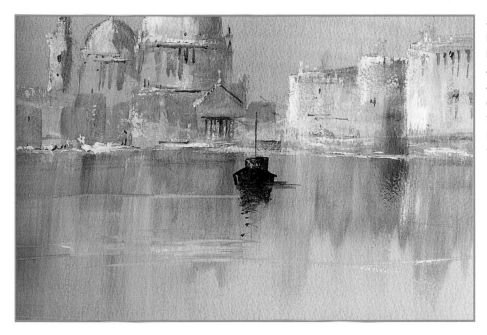

22. I also noticed that there was a large distance between foreground and background, so I decided to add a boat as a 'stepping stone' between the two. Use a dark blue mixed from ultramarine and cadmium red light and the rigger brush to paint a silhouette of a small boat and its reflection in the middle distance. Leave to dry.

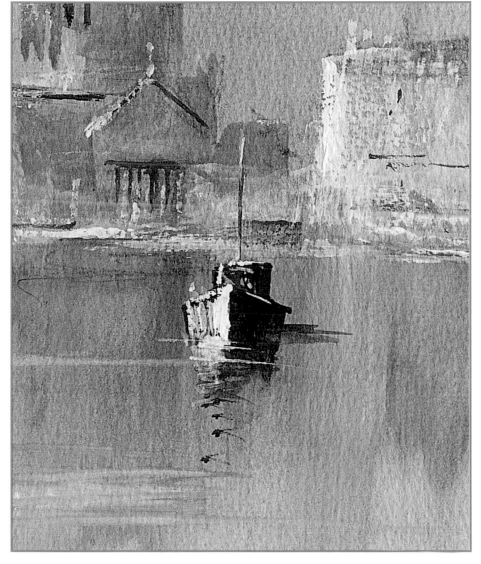

23. Now use neat titanium white to paint the sunlit side of the boat and small highlights on the superstructure and mast. Finally, use titanium white to amend the reflection.

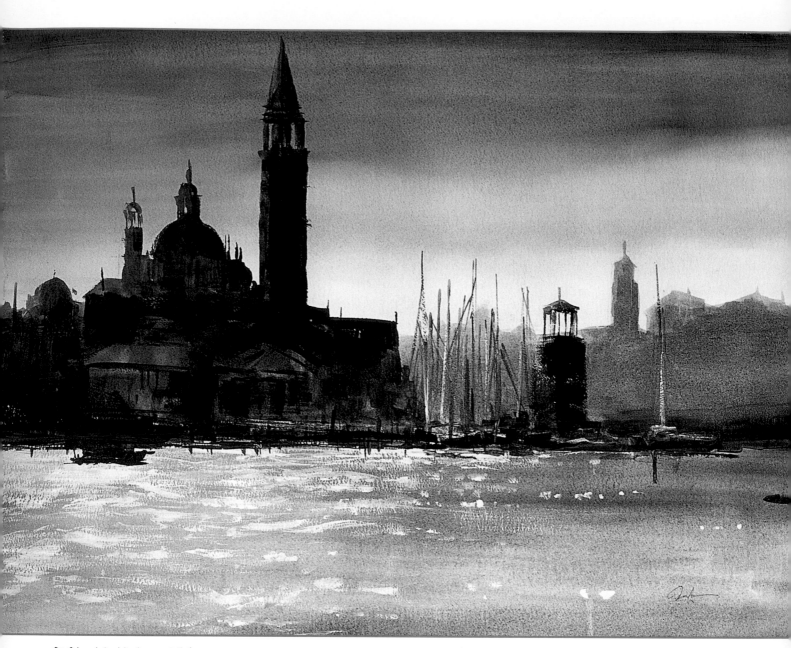

St Giorgio's, Venice, at Night

760 x 560mm (30 x 22in)

The sky was painted onto watercolour paper which had been wetted to ensure that no hard edges developed. This soft and wet effect contrasts with the hard, rough edges of the nearest buildings. The buildings were painted in with a thirsty brush, dry in wet. The lights on the water were placed using a round brush and thick titanium white. The masts were painted in using a rigger brush.

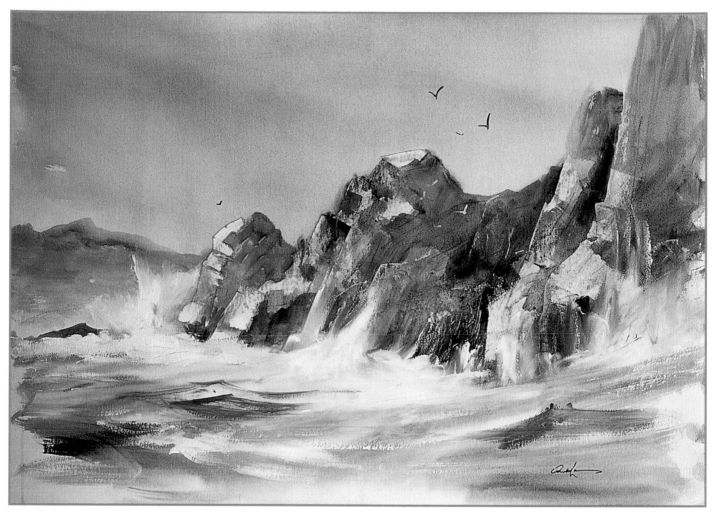

Rough Seas on the Welsh Coast
760 x 560mm (30 x 22in)

This painting also shows both watercolour and oil techniques. The sky was painted transparently, as in the step-by-step demonstration. The dark rocks were painted in thickly and the light area scraped out with a safety razor blade. The sea area was wetted and the dark waves painted in with little water. They retained their shape but were left with soft edges. The foam and spray were applied using neat titanium white with a finger. The birds were added with a rigger brush and to give the rocks scale.

Misty Harbour

GLAZING WITH WHITE

For this project I wanted to paint a small harbour with a distant shoreline, boats in the middle distance and another boat and a harbour wall in the foreground. What appealed to me about the scene was the misty atmosphere, and I decided to achieve this by using acrylic glazes. I painted the scene first as a clear, bright day. When it was dry, I glazed on a mix of titanium white with gloss medium and varnish and water to create the fog.

High quality glazes can be produced in acrylics by adding a lot of medium with a little colour and some water. The medium is pure acrylic polymer and can be obtained in a gloss or matt finish. It is milky in colour when wet but dries clear, just like wood working glue. If you mix fifty per cent medium with fifty per cent water and then add a little colour, you are ready to apply your glaze. It will lie as a thicker than normal semi-transparent layer over your initial painting. This additional thickness spreads the paint pigment three-dimensionally and allows the light to filter through so that the underpainting can still be seen.

The old masters glazed their oils in this way using linseed oil as the medium instead of acrylic polymer. The paintings took many weeks to dry and some had up to thirty-five layers of glazing. This is quicker!

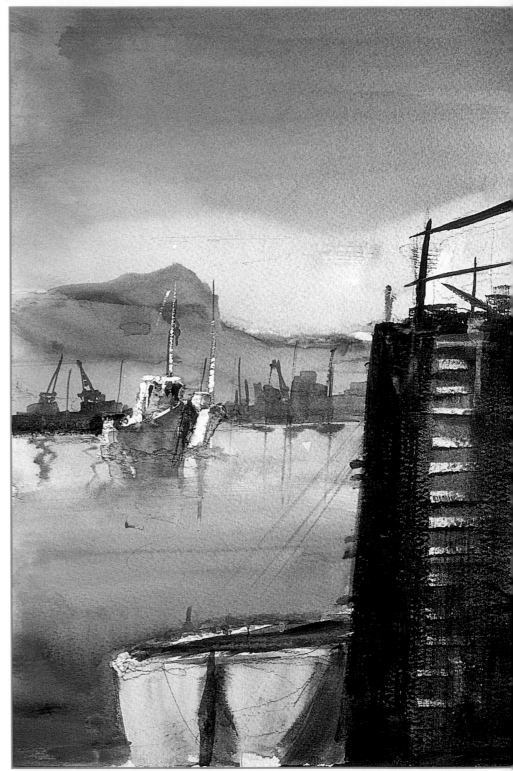

This is the painting before glazing. I exaggerated the contrasts between light and dark to allow for the fog layers that would later be applied.

Opposite

The finished painting.

You will need

The original painting on a 280 x 380mm
(11 x 15in) sheet of NOT 300gsm
(140lb) watercolour paper

Colours for the original painting:
 phthalo blue
 permanent rose
 cadmium yellow
 burnt sienna
 burnt umber
 ultramarine blue

For the glaze:
 titanium white

Gloss medium and varnish

50mm (2in) flat brush

Rigger brush

Hairdryer

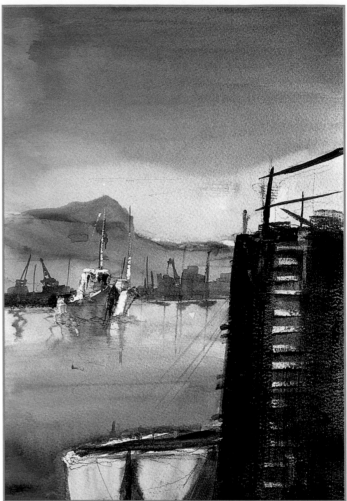

1. Paint the subject with the colours you would
use on a sunny day, then leave to dry.

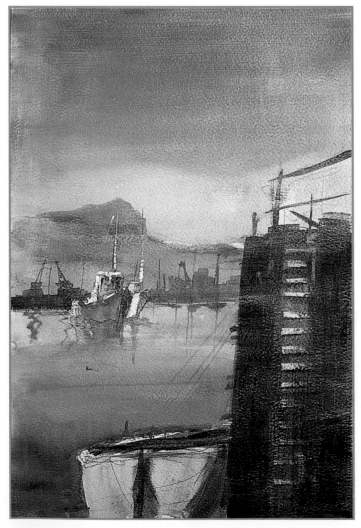

2. Mix some gloss medium and varnish and water together in a
fifty–fifty ratio. Nudge into this mix a small amount of titanium
white to create a milky finish. The fog glaze is now ready to apply.
Use a 50mm (2in) flat brush to apply the glaze over the whole of
the painting. This first glaze knocks back all the bright colours,
which, even in the foreground, will be somewhat muted by mist.
Use the hairdryer to dry the glaze. It is better to apply more glazes
thinly than one thick glaze, which will spoil the effect

> **TIP**
> Ensure each glaze is dry before applying the next, or
> you will pick up colour from the layer beneath.

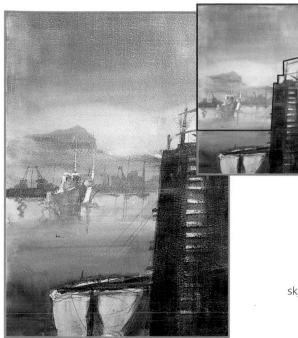

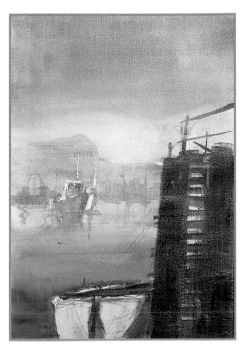

4. Add a third white glaze to the sky area and bring it down to cover the distant mountains.

3. Now apply another white glaze but, this time, only cover the area that is more than about 50m (50 yards) away, then dry this glaze completely. In the inset diagram above, the area to be covered by the second glaze is bounded by red lines.

5. Finally, redefine the darks of the harbour wall using ultramarine blue and burnt umber, then use the rigger brush to redefine the mooring ropes.

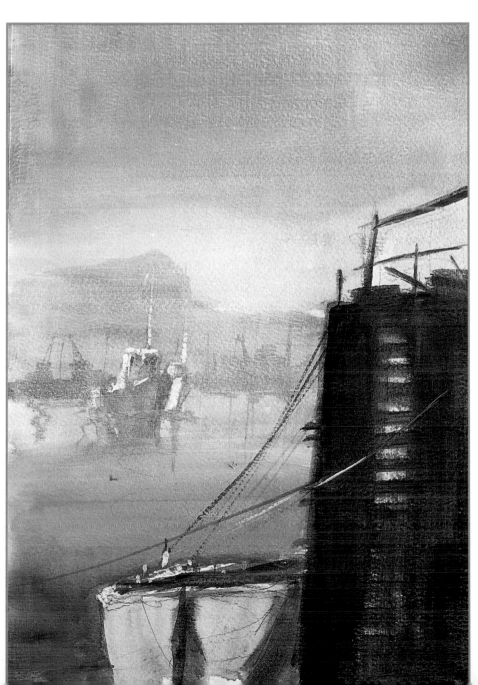

Evening Solitude

GLAZING WITH COLOURS

I wanted to show the light shining from the cottage window in the dark and its reflection across the lake.

I didn't want to lose the details of the cottage so I initially painted it in daylight. When it was dry, I glazed successive coats of colour using gloss medium and varnish for transparency, slowly turning the day into night. The transparency is maintained and the cottage details are still visible.

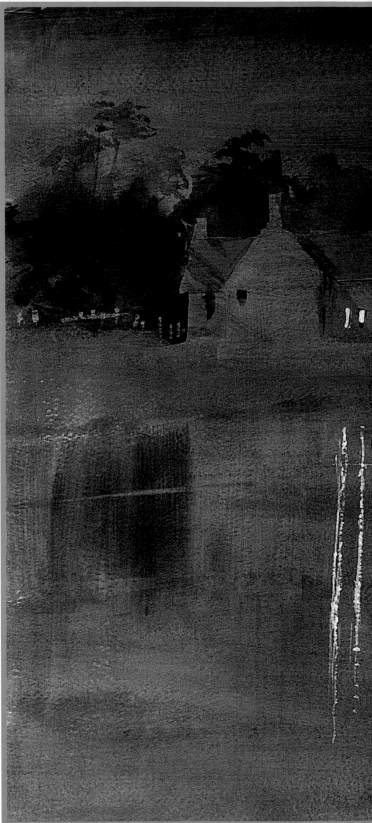

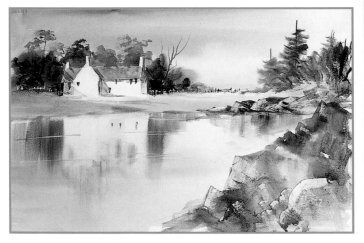

The sky in the initial painting was phthalo blue with a touch of cadmium red light. The roof was cadmium yellow and cadmium red light. The background trees were mainly phthalo blue and burnt umber mixed. A variety of warmer colours were added to create interest and to counter the cool colours of the sky and water.

The finished painting.

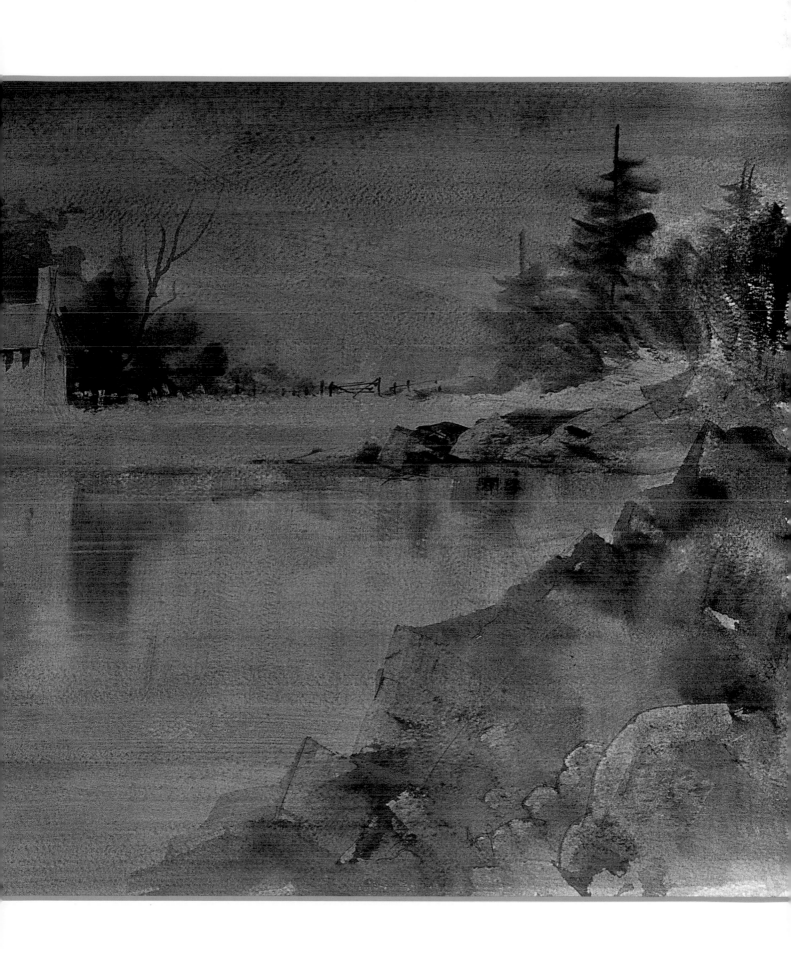

You will need

The original painting on a 560 x 380mm (22 x 15in) sheet of NOT 300gsm (140lb) watercolour paper

Colours for the original painting:
 cadmium yellow
 cadmium red light
 phthalo blue
 burnt sienna
 burnt umber
 ultramarine blue
 titanium white

Colours for the glazes:
 cadmium yellow medium
 permanent rose
 ultramarine
 dioxazine purple

Gloss medium and varnish

50mm (2in) flat brush

No. 3 rigger brush

Hairdryer

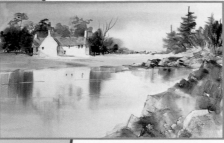

1. Paint the subject as it appears in daylight, complete with reflections.

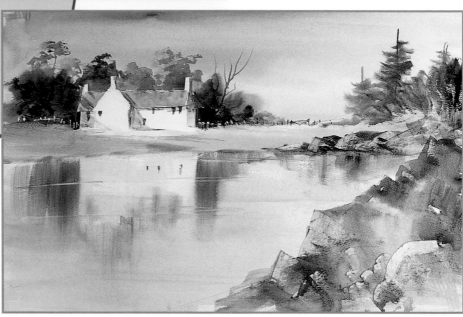

2. Prepare a fifty–fifty mix of water and gloss medium and varnish and add a little cadmium yellow to produce a glaze. Brush this over the whole painting. Dry the glaze completely.

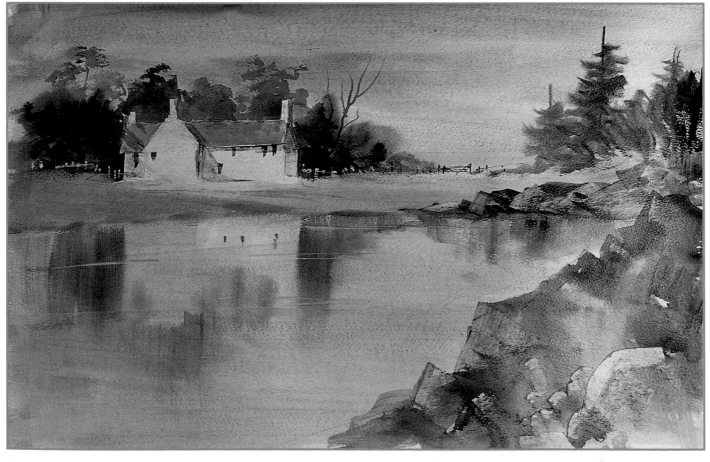

3. Prepare a glaze of permanent rose and brush this over the whole painting. Dry with a hairdryer.

4. Apply a glaze of ultramarine in the same way.

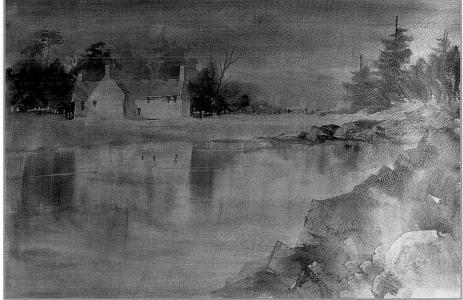

5. Apply a glaze of dioxazine purple.

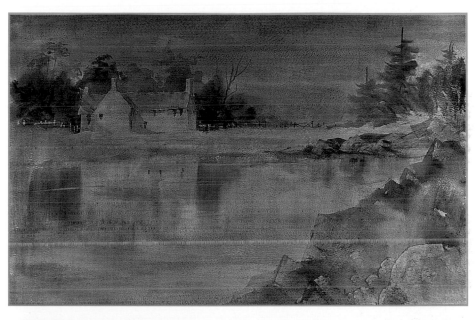

6. Apply a strong glaze of ultramarine mixed with dioxazine purple.

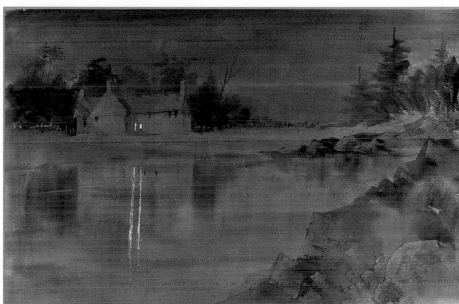

7. Finally, turn on the lights with touches of titanium white painted over a couple of the windows, then paint their reflections on the water.

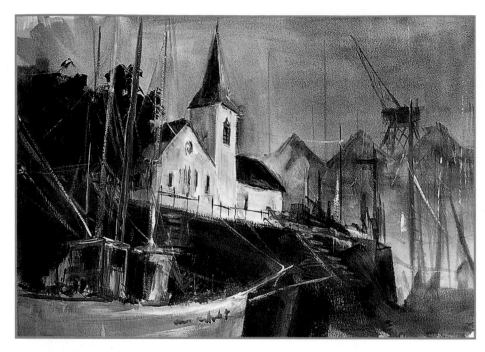

Norwegian Church, Cardiff Docks
760 x 560mm (30 x 22in)

The initial painting was created very loosely and a few glazes using gloss medium and varnish were then applied.

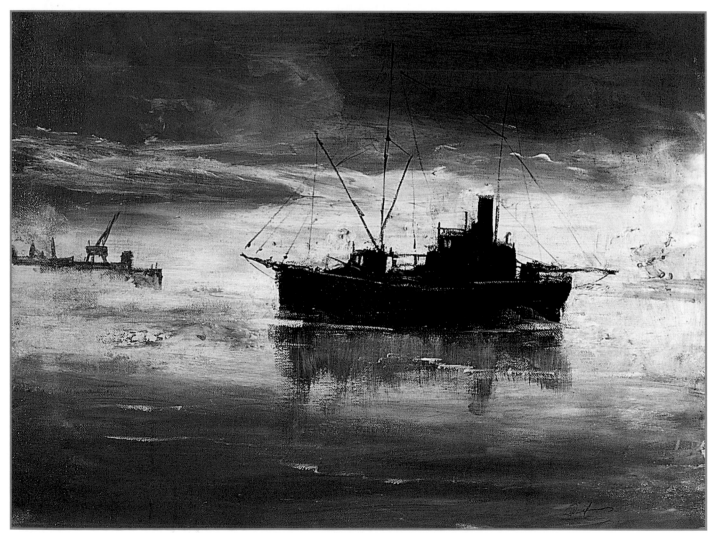

Trawler at Dawn
560 x 460mm (22 x 18in)

This was painted on canvas board. The original was painted almost as a monotone and then glazed with a number of different colours mixed with gloss medium and varnish.

If You Go Down to the Woods...
760 x 560mm (30 x 22in)

The shadows in this painting were applied with a mix of colour and gloss medium and varnish to get the transparent quality. This was painted over the dried underpainting.

Rocks in a Landscape

USING PASTES AND GELS

This last project highlights the colour power and intensity achievable with acrylics. My chosen subject was the beautiful woods at Westonburt, near Stroud. The reasons I chose the scene were the fantastic colours that can be seen in the autumn and also the fact that I like rocks! I decided to use intense colour and also modelling paste and texture gel to give a feeling of the place.

There are a large number of acrylic-based materials which allow you to produce special effects in your paintings. For this painting I used modelling paste and a texture gel called black lava. Modelling paste comes in different densities but generally it is acrylic medium with a body filler to allow it to be trowelled onto the surface thickly or modelled into shapes. This was used to create some rocks. Black lava paste is an acrylic medium mixed with many small black granules which, when spread onto a surface, can create the texture of a shingle beach or road.

The finished painting.

The sketch provided the size, placement and overall shapes of the rocks together with the position of the path, both of which are crucial to the composition.

84

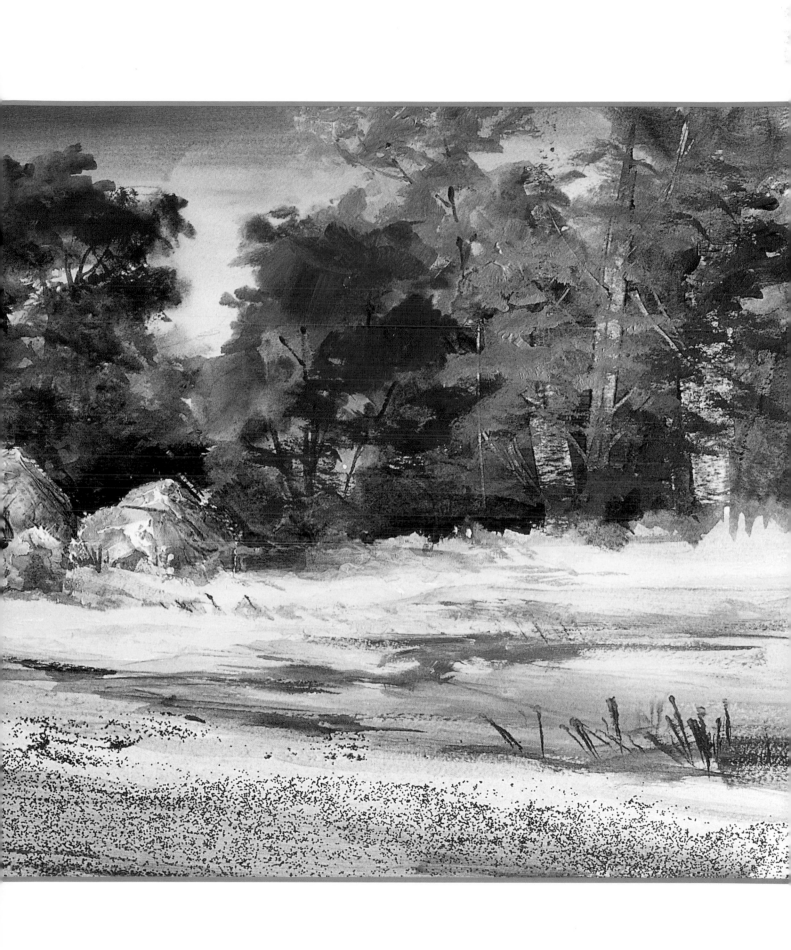

You will need

560 x 385mm (22 x 15¼in) sheet of
NOT 300gsm (140lb) watercolour
paper

Soft pencil

Colours
ultramarine
cadmium red light
permanent rose
cadmium yellow medium
cadmium orange
yellow ochre
brilliant yellow green
burnt sienna
titanium white

Mediums
medium and varnish for glaze
modelling paste

Black lava texture gel

Painting knife

25mm (1in) flat brush

No. 3 rigger brush

Razor blade

Medium grade sandpaper

Putty eraser

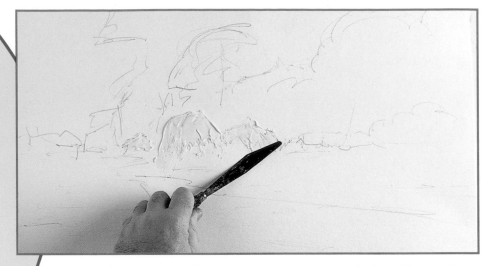

1. Draw the basic outline of the composition, then use a painting knife to apply the modelling paste to the rocks. Leave it to dry naturally (remember that the thicker the layer, the longer the paste takes to dry).

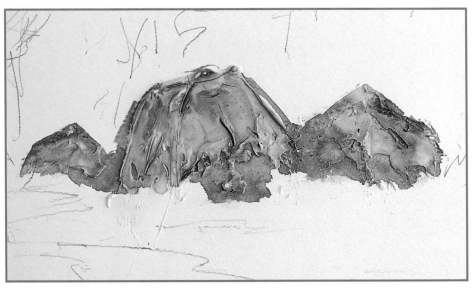

2. Mix ultramarine with touches of cadmium red light to create different tones of grey, then use the 25mm (1in) flat brush to paint the dry modelling paste rocks. Introduce touches of cadmium yellow here and there, then leave to dry completely.

3. Use a razor blade to scrape off the top, sharp edges of the modelling paste to create highlights.

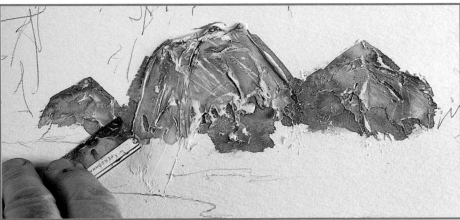

TIP
Let the modelling paste dry naturally over about half a day. If you use a hairdryer, it might appear dry on the surface, but you will find it soft inside when you try to scrape it.

4. Use the medium grade sandpaper to roughen the flatter surfaces of the modelling paste slightly, then clean off any loose particles of dust and grit with a putty eraser.

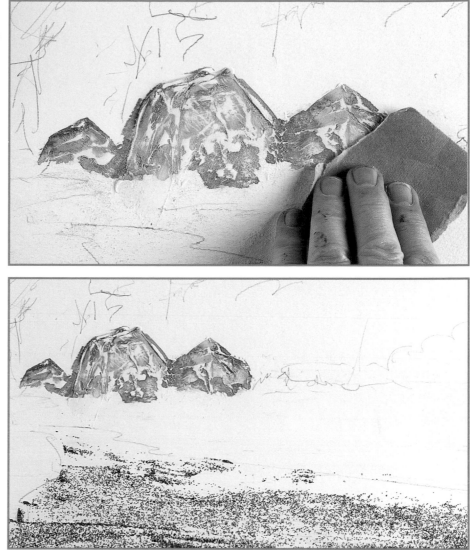

5. Use the painting knife to spread black lava texture gel across the foreground of the path that leads the eye to the rock formation. Spread the gel thinly like butter.

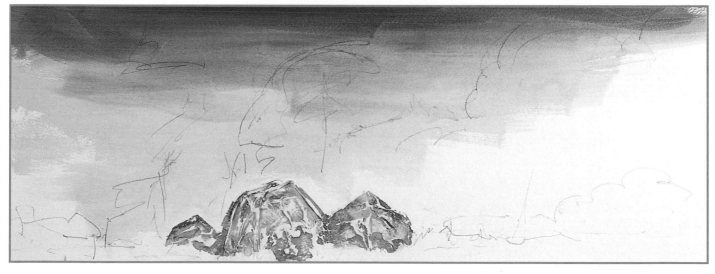

6. Use the 25mm (1in) flat brush to block in the sky wet on dry. Start by painting cadmium yellow over the sky area, taking it across into the trees on each side. While the yellow is still wet, strengthen the tone across the top of the sky with cadmium orange followed by some burnt sienna. Blend the colours to soften the edges.

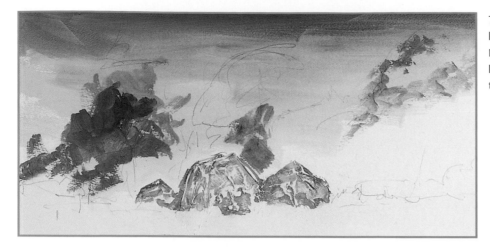

7. Use cadmium orange and cadmium red light to start defining the trees at each side. Make the marks stronger and bulkier at the left-hand side, weaker and less defined at the right-hand side.

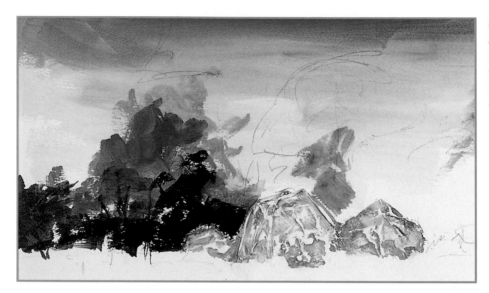

8. Mix some darks from cadmium red light and ultramarine, then block in the foliage behind the rocks. Soften the top edges of these marks with clean water on a damp brush. Use the tip of the brush to indicate a few tree trunks.

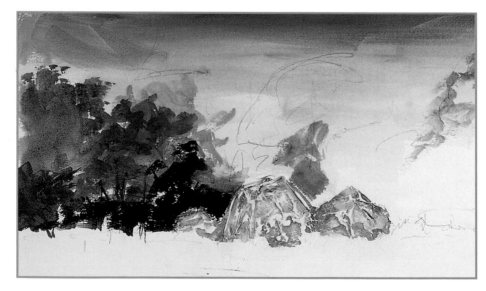

9. Use a weaker wash of cadmium red light with less ultramarine than before to work up the trees at the left-hand side.

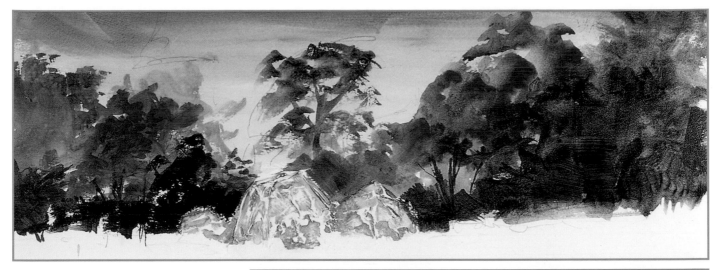

10. Mix various tones of cadmium orange and ultramarine, then develop the trees at the right-hand side, adding touches of cadmium red light for leaves as the colours underneath dry. Use a weak wash of ultramarine with a touch of cadmium red light to add the distant tree behind the rocks. Block in the undergrowth at the extreme right-hand side with mixes of ultramarine and permanent rose.

11. While the paint is still wet, use a series of horizontal strokes of the razor blade to create some wide tree trunks, then use the handle of the scraper brush to lift out thinner trunks and branches.

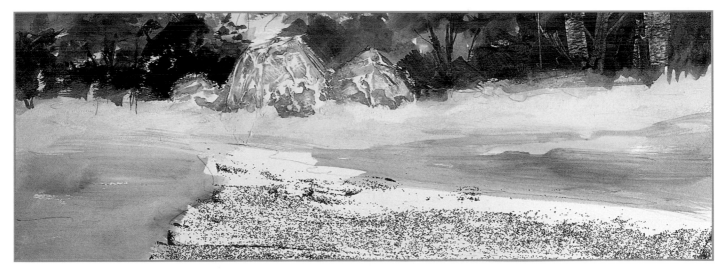

12. Block in the grassy area on either side of the rocks with brilliant yellow green and the flat brush. While the green is still wet, introduce touches of cadmium yellow at the top and bottom, then block in the foreground with tones of cadmium orange. Leave to dry.

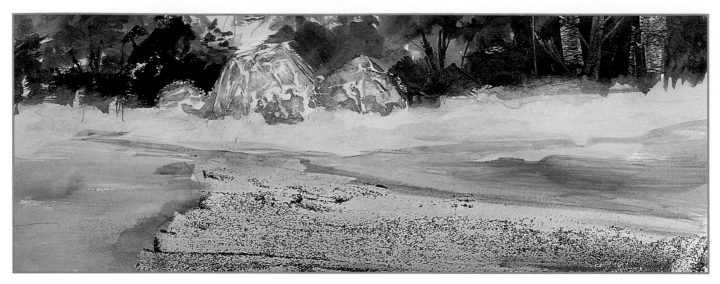

13. Prepare a weak glaze from ultramarine mixed with medium and varnish, then glaze this over the more distant part of the path. Introduce touches of cadmium red light to the glaze as you work forward, then touches of cadmium orange in the foreground. Leave the painting until the glaze is completely dry.

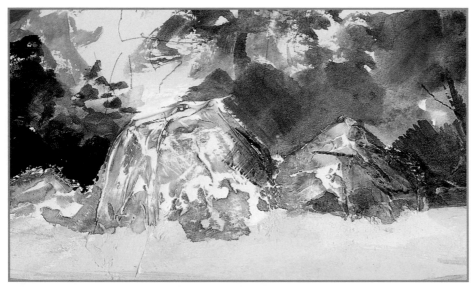

14. Use a blue-grey mix of ultramarine, permanent rose and medium and varnish to add shadows at the right-hand side of the two large rocks. Then, using various tones of the glaze, continue to build up the shape and form of the rocks.

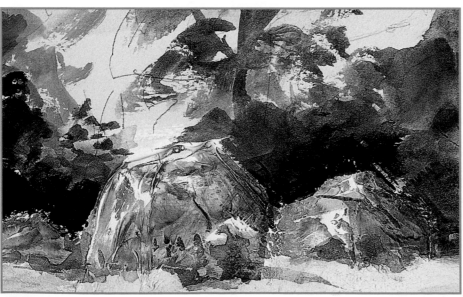

15. Mix a dark blue from ultramarine and permanent rose, then lay in some dark foliage behind the rocks. Use clean water to soften the top edges of these marks. At this stage I was not happy with the shape of the right-hand rock, so I removed its pointed top by painting over it with the background colour.

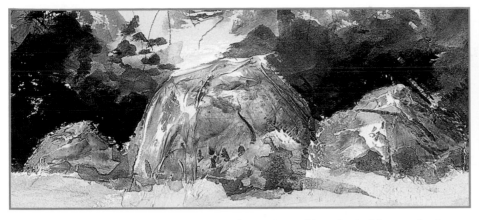

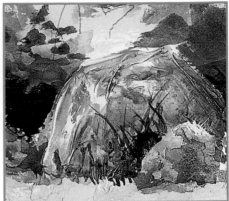

16. Develop the sunlit areas on the rocks with titanium white mixed with a touch of cadmium orange.

17. Use the rigger brush and a dark mix of cadmium red light and ultramarine to indicate some grasses and other foliage at the base of the largest rock.

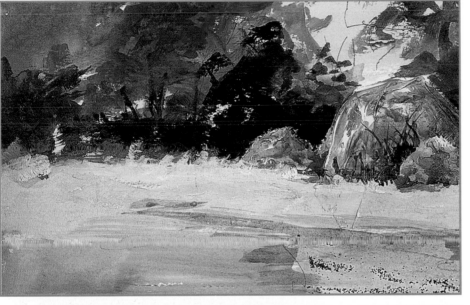

TIP
If you keep the tones between the rocks and the ground similar, they look as though they are coming out of the ground, not stuck on it!

18. Change to the 25mm (1in) flat brush, then use brilliant yellow green mixed with a touch of titanium white to develop paler tones in the distant grassy ground at the left-hand side of the rocks.

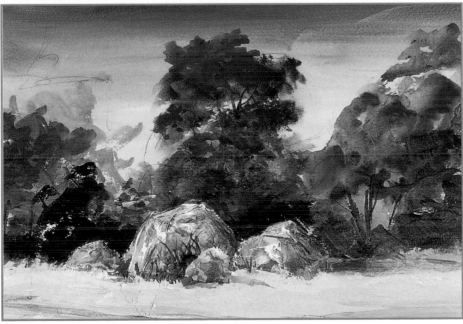

19. Wet the sky area, then using cadmium red light mixed with touches of ultramarine, redefine the foliage on the distant tree in the centre of the composition. Soften the top edges of these marks with water, then use the rigger brush and darks from your palette to add some branches.

91

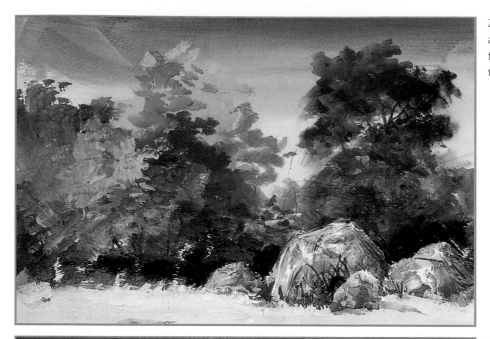

20. Use cadmium yellow, cadmium orange and cadmium red light to rework the foliage and trees at the left-hand side of the painting.

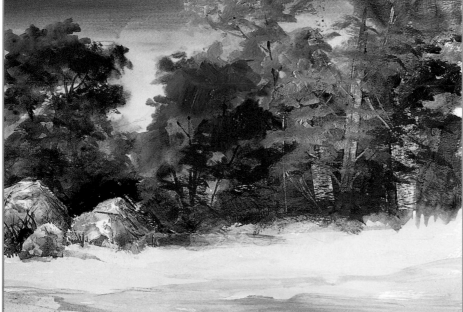

21. Use the same colours to rework the trees at the right-hand side, then add touches of permanent rose to the lower foliage. Introduce yellow ochre to counter the brighter reds and some burnt sienna at the extreme right. Finish the trees by adding some branches using the rigger brush and the darks on the palette.

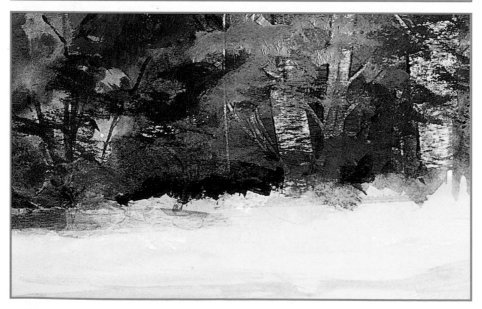

22. Mix dark tones from ultramarine and permanent rose, then lay in some dark foliage at the base of the trees at the right-hand side to emphasise the lighter tones of the distant grassy ground.

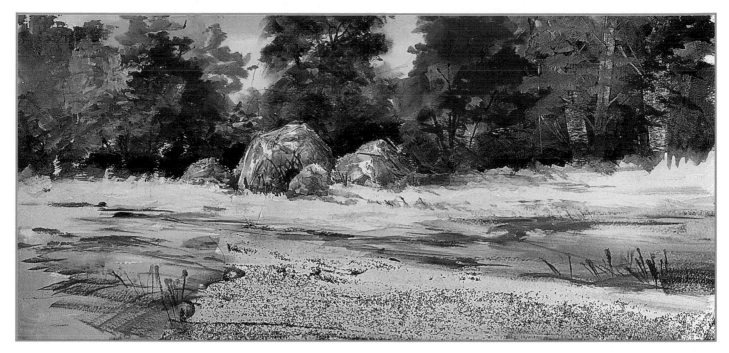

23. Define the edges of the path with mixes of ultramarine and burnt sienna; make a broken line with random brush strokes. Using a dabbing action with the 25mm (1in) flat brush loaded with brilliant yellow green, create the texture of clumps of grass on the more distant ground. As you work forwards, introduce touches of yellow ochre, cadmium orange and cadmium red light, and make the marks more pronounced. Leave the painting to dry.

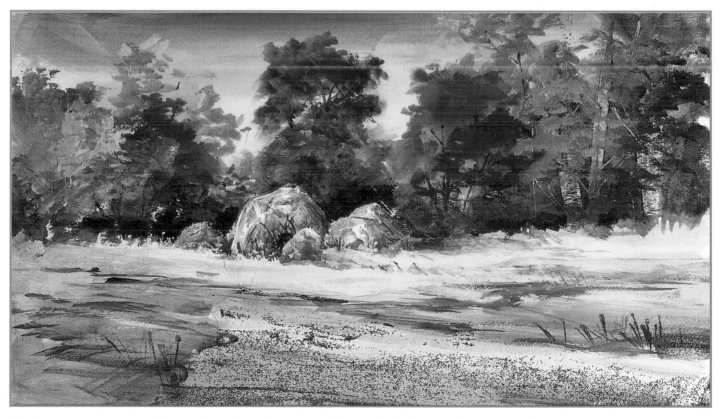

24. Prepare a weak glaze of ultramarine and medium and varnish, then lay in long cast shadows across the foreground from the left-hand side.

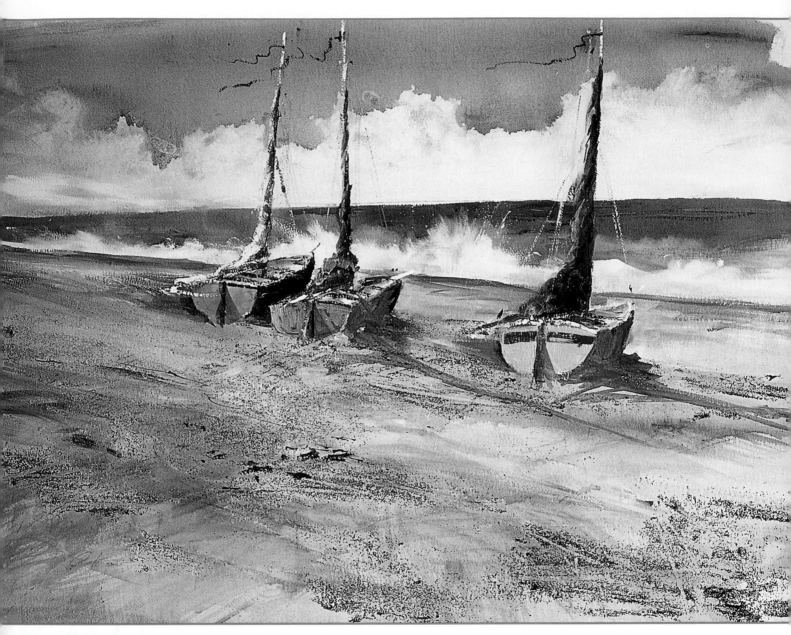

All Ashore

760 x 560mm (30 x 22in)

The sky was put in with a wet wash and the clouds were dabbed out with a paper tissue while the paint was wet. The sea was painted in and the waves quickly sponged out whilst wet (you have to keep cleaning the sponge when using this method). After the boats were painted, some black lava texture gel was applied to the beach and left to dry. This gave the shingle appearance. Thin washes of raw sienna and burnt sienna with gloss medium and varnish were glazed on top to give the beach its final colour. The shadows of the boats were applied in the same way.

Lae Rock

650 x 400mm (25½ x 15¾in)

The rock was created with modelling paste, glazed then sanded down when dry. Shadows were glazed on top afterwards. The waves were applied with a finger using titanium white.

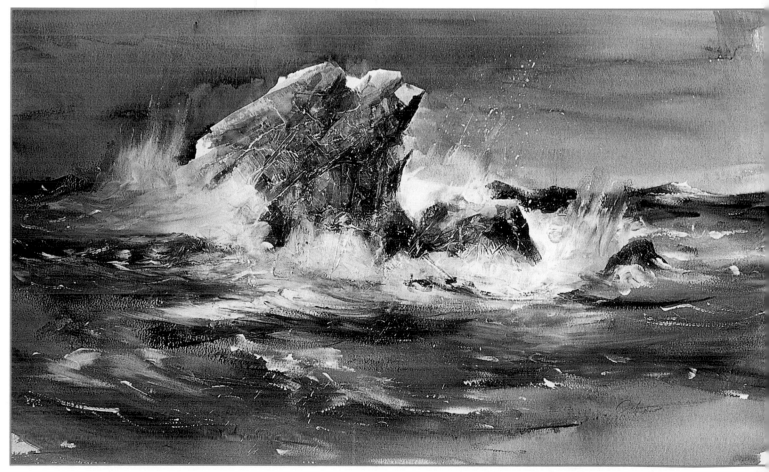

INDEX

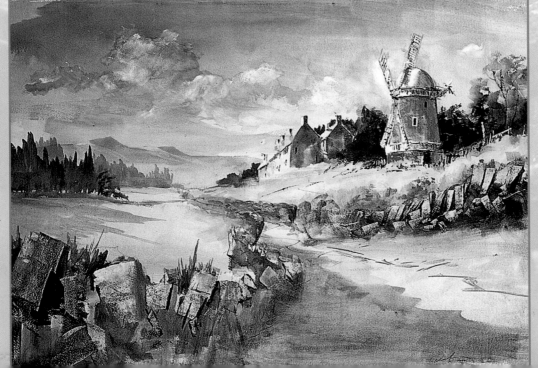

Windmill
760 x 560mm (30 x 22in)

Although the path leads to the left, I made the windmill powerful enough to force the viewer's eye to the right when it reached the end of the path. The shadows were glazed on afterwards with a mix of paint and gloss medium and varnish.